IMAGES
of America

FLATONIA

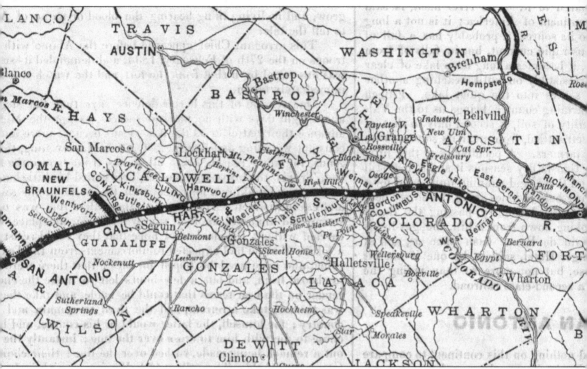

Flatonia is located in the southwest corner of Fayette County, Texas, and in 1874 the town moved two miles northwest to its current location directly on the path of the Galveston, Harrisburg & San Antonio Railway. When the *Immigrants Guide to Western Texas* was published in 1876, the line had not yet been completed as far as San Antonio. The guide's foldout map shows several older communities that faded into obscurity as new market centers arose adjacent to the newly constructed railroad and its shipping points. (E.A. Arnim Archives and Museum.)

ON THE COVER: Located in the middle of a large livestock producing region, Flatonia has had many thriving feed stores through the years. Lonnie Garbade Sr. began the Flatonia Hatchery and a feed store in about 1933. Pictured some years later in the warehouse are, from left to right, unidentified, Lonnie Garbade Sr., Emil Janak, and Alfred Barta. (Family of Frances and Lonnie Garbade Sr.)

IMAGES
of America

FLATONIA

Judy Steinhauser Pate and
the E.A. Arnim Archives and Museum

ARCADIA
PUBLISHING

Published by Arcadia Publishing
Charleston, South Carolina

Library of Congress Control Number: 2017956870

For all general information, please contact Arcadia Publishing:
Telephone 843-853-2070
Fax 843-853-0044
E-mail sales@arcadiapublishing.com
For customer service and orders:
Toll-Free 1-888-313-2665

Visit us on the Internet at www.arcadiapublishing.com

*To all the people, past and present, who have left their
indelible marks on Flatonia and the surrounding area*

CONTENTS

ACKNOWLEDGMENTS

This book would not have been possible without those who have so generously shared their photographs, recollections, and stories with the E.A. Arnim Archives and Museum (EAAAM). The donor or source of each photograph reproduced herein is credited in parentheses following the caption.

In addition to all the individuals who have donated or loaned precious family photographs, I would also like to thank the Fayette Heritage Museum & Archives, the Muldoon Museum, and the Mt. Olive Museum & Cultural Center for sharing photographs from their collections. Special thanks, too, to all who provided historical insights into these photographs, to all who helped with proofreading the manuscript, and to the patrons and the board of directors of the E.A. Arnim Archives and Museum for their ongoing support.

The pages that follow contain many photographs of Flatonia's first 100 years that have been handed down through generations. These windows to the past have been an endless source of joy and interest to me and to countless museum visitors. They have illustrated a history of the area that I scarcely knew existed. Though not all could be incorporated into this book, it is to be hoped that these photographs will tell much of that story and that the story will continue to be told through many more photographs yet to be discovered.

INTRODUCTION

The gently rolling hills of southwestern Fayette County, Texas, remained sparsely populated through the first half of the 19th century. The county's Hispanic population temporarily declined in the years immediately following Texas independence in 1836 and encounters with Native Americans became more infrequent. Anglo-Americans had settled the northeastern reaches of the county, including what would become the county seat of La Grange, as early as the 1820s and 1830s but it was not until the 1850s that these settlers began arriving in significant numbers further south and west of the Colorado River. They came primarily from the southern states—many bringing slaves with them—setting up as farmers and ranchers and establishing small trading centers such as Pin Oak, Blackjack, Oso, Cistern, and Mount Pleasant.

By the 1860s, the promise of cheap and fertile land was attracting many German and Czech immigrants as well. Often preferring to live in communities where they shared a common language and culture, many Czechs settled around New Prague (Praha), and Germans formed a colony that was named Flatonia after successful merchant and early postmaster F.W. Flato.

The Civil War slowed immigration dramatically and entirely halted the westward push of railroads through Texas. By the 1870s, however, the construction of the Galveston, Harrisburg & San Antonio Railway had transformed this part of the county. Knowing that it would bring an influx of new settlers to the area, local entrepreneurs F.W. Flato, John Cline, and John Lattimore negotiated an agreement with railway president T.W. Pierce that determined the iron horse's route through the region.

In 1873, railway engineer John Converse platted a "new" town of Flatonia on 160 acres of land acquired from the Faires family. The post office, shops, and most of the inhabitants of "old" Flatonia soon moved about two miles to the northwest to be near the new depot, with many from the other nearby communities following suit. The first train arrived in Flatonia in April 1874, and by July 2, a *Galveston Daily News* article reported this about the infant town:

> Some sixty buildings grace the town, including seven stores, five barrooms, three hotels, two drug stores, blacksmith shop, two barber shops, tin and saddlery shops, and some five lumber yards deal out plank at living figures. Five gin mills are in full blast, and, as I write, one can see that they are well patronized.

By late 1875 Flatonia had incorporated, with T.W. Amsler as its first mayor. To promote land sales and continuing prosperity—both for itself and for the territory it traversed—the Galveston, Harrisburg & San Antonio Railway produced an *Immigrants Guide to Western Texas* in 1876 that describes each of the towns along what it dubs the "Sunset Route." This publication portrays Flatonia as one of the most promising of the new towns of Texas:

> Up to November 15, the shipment of cotton for the season opening September 1st had been 4000 bales. There is a good church and school-house. There are fourteen business houses, including one bank, that of F.W. Flatto [sic], Jr. Good water can be had by digging forty feet. There are a number of steam saw mills and gins in the vicinity of Flatonia. Gray sandstone of good quality is found within a convenient distance of the town. Good prairie lands may be purchased in the vicinity of the town at from three to eight dollars, and timber lands at from ten to fourteen dollars. The county is fine and rolling, with post and live-oak timber.

In the decade between 1876 and 1886, Flatonia developed a new air of permanency. Its merchants prospered, and many replaced their early frame storefronts with substantial rock and brick buildings. Even greater prosperity was anticipated with the construction of a second railway through Flatonia in 1887. The San Antonio & Aransas Pass Railway crossed the older Galveston, Harrisburg & San Antonio line just west of the downtown business district. Inevitably, however, this new north–south line led to the growth of competing market towns, such as Muldoon to the north and Moulton to the south. As one citizen, W.A. Beckham, notes in his memoir, "It had already become apparent that our expectations of a considerable city had to be modified." New railroads were crossing the territory, new towns had been established along these lines, and Flatonia's trade territory was shrinking. Beckham continues, "Many of the folks who were here in the boom days had departed but there were more substantial buildings taking the place of the shacks."

Despite a slump in the local economy at the close of the 19th century and the early years of the 20th century, a recovery was under way by 1910. A group of energetic businessmen formed the "Flatonia Committee" to actively seek and procure several small industries. Most of these were engaged in the processing or distribution of farm products, but a new ice and electric plant was established as well.

As young men returned to the workforce in 1919 after World War I, another national trend would be reflected in the local economy. The first automobiles had arrived in Flatonia as early as 1909, but now more and more people were acquiring them for their personal transportation needs. A slow but inexorable shift away from the railroad to the open road had begun.

Even so, with its usual perseverance, Flatonia managed to maintain its position on a major east–west thoroughfare. Local citizens lobbied hard to see that the Old Spanish Trail, one of the nation's first named coast-to-coast tourist highways, would pass through the downtown commercial area, right along North Main Street. As harness and saddle shops closed and buggy sales diminished, automobile showrooms, garages, filling stations, roadside eateries, and a drive-in motel sprang up along the new highway.

Although Flatonia certainly felt the effects of the Great Depression and its economy slowed, surprisingly few bankruptcies occurred. Farmers probably experienced the harshest impact, but "trade days" still managed to bring great numbers of shoppers to town for special promotions and entertainments. Flatonia's small industries survived the lean times, and on the eve of World War II the town was well prepared to do its part, supplying men and materials for the effort—just as it had in World War I.

At the close of the war, more and more young men and women chose to seek their fortunes in the cities rather than return to life on the farm. Combined with changing agricultural practices and decreasing productivity of the local farmland, this trend would continue for decades after.

Meanwhile, transportation would once again play a role in Flatonia's destiny. Railway service continued to decline, particularly for passenger traffic. And although Flatonia had seen to it that the new federal highway, US 90, followed the same route as the Old Spanish Trail through the downtown commercial district, a car in every garage meant local citizens could travel farther afield for their shopping needs.

It was not until Interstate 10 was completed as far as Flatonia in 1970 that the steady flow of coast-to-coast traffic was finally diverted a few blocks away from the town's historic center. Its commercial resilience, however, along with much of its 19th-century architecture, remained. The 1973 centennial celebration closed out one century of progress through transportation while demonstrating that Flatonia had not lost its potential for growth and good living. It was just beginning to find new ways of getting there.

One

RAIL CROSSROADS
OF TEXAS

When the Galveston, Harrisburg & San Antonio (GH&SA) Railway chose a path through southern Fayette County, it bypassed the existing village of Flatonia. The name and the town simply moved and resettled by the new depot and Flatonia's long marriage of rail and commerce began.

The GH&SA Railway ran east and west, bisecting a business district that grew up in a mirror image on both sides of the tracks. In later years, this line would be known by several other names—the Texas & New Orleans Railroad, then Southern Pacific, and finally Union Pacific—but by whatever name, it was an ever-present feature of the local scene.

Flatonia's railway infrastructure continued to grow through the years. After the north–south San Antonio & Aransas Pass (SA&AP) Railway crossed the older GH&SA line on the west side of town in 1887, each company maintained its own freight and passenger depots. In the early 1890s, a major spur line was added down the middle of Seventh Street, one block north of North Main Street, to facilitate shipping for a growing number of small industries.

In 1902, the GH&SA Railway added an interlocking mechanism and tower at its crossroads with the SA&AP Railway to control traffic and switch trains from one rail line to another. Finally, in 1926, a new passenger station was built at this junction, greatly facilitating passenger transfers between the two lines.

The coming of the railroad opened the interior of Texas to a world of new possibilities. Those with means could travel the world, whether to see a world's fair or to take a ship to Europe. And just as Flatonia could transport carloads of cattle and produce to markets in Chicago or New Orleans, local stores were stocked with goods that arrived by rail from the great markets of St. Louis or New York. In 19th-century Flatonia, a single day's shopping might net everything from a fashionable hat to a fine piano, from fresh oysters harvested in Berwick Bay, Louisiana, to a Milburn wagon made in Ohio—finding a variety of goods in main street shops that would remain matchless in later, more "advanced" times.

F.W. Flato was the prominent merchant, postmaster, and entrepreneur for whom Flatonia was named. Flato, John Cline, and John Lattimore brokered a land deal with the railway that moved the community to its present site. Flato was very influential in Flatonia's early development, promoting land sales as well as engaging in such ventures as a brick factory, a pottery kiln, a steam sawmill, and a brewery. (Judy and Doug Meier.)

The Galveston, Harrisburg & San Antonio Railway was very active in advertising the attractions of new rail towns along the length of the line. This lithograph appears in the company's 1876 *Immigrants Guide to Western Texas*. It is the first known pictorial representation of Flatonia and shows the original frame buildings along South Main Street, with one of the town's many early saloons prominently in the forefront. (EAAAM.)

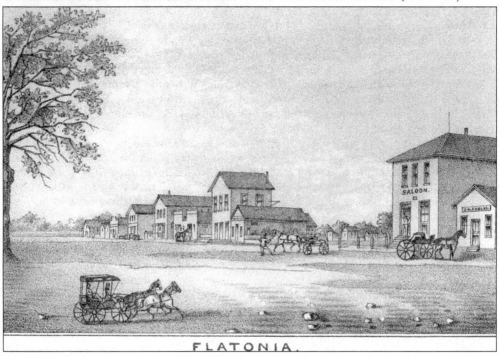

FLATONIA.

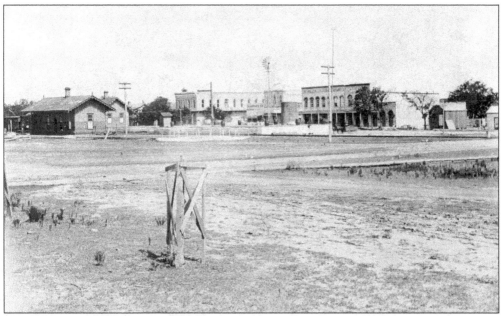

Almost all the original frame buildings in the business district had already been replaced by rock and brick structures by the time this photograph of North Main Street was taken in the 1890s. The passenger and freight depots seen at the far left were exceptions, as were the windmill and the large wooden cistern that held the town's main public water supply at that time. (EAAAM/ Jeanne Nikel.)

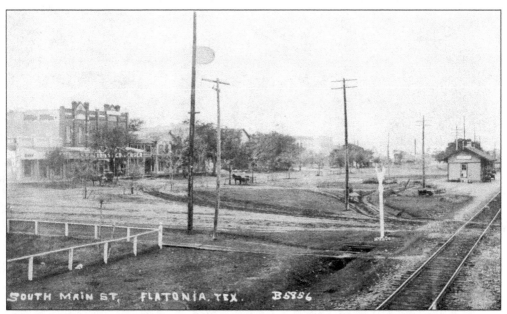

This photograph of South Main Street shows the three oldest brick buildings in town, constructed from 1879 to 1880. A 1915 fire destroyed the Central Hotel, the frame building just to their right. Both photographs on this page illustrate the wide space left deliberately open between the railroad tracks and the two main streets facing them. (EAAAM/Betty and W.W. "Sweet" Mueller.)

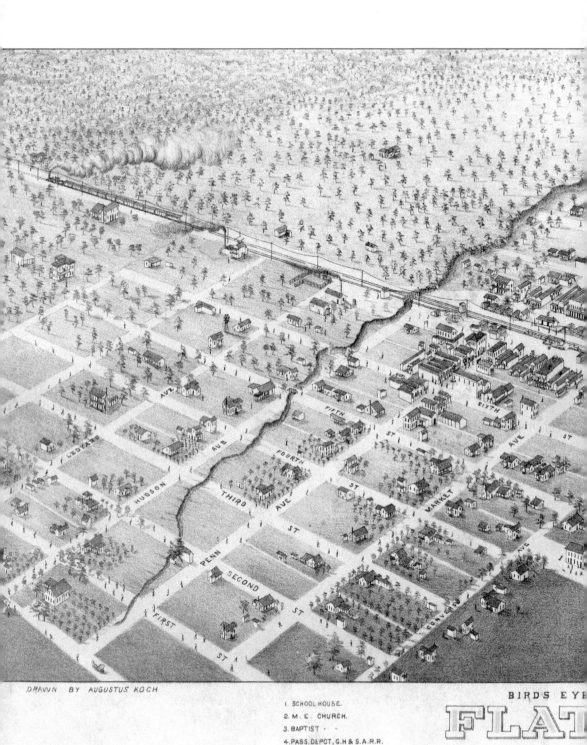

DRAWN BY AUGUSTUS KOCH

1. SCHOOL HOUSE.
2. M. E. CHURCH.
3. BAPTIST.
4. PASS. DEPOT, G.H & S.A.R.R.

BIRDS EYE

FLAT

FAYETT

This lithograph portrays Flatonia as it was in 1881 when Augustus Koch (1840–1899) produced it for sale to local citizens. Koch specialized in these so-called bird's-eye views of cities and towns across Texas. He would draw the streets and buildings in great detail and then produce these "maps" as if the town were seen from a perspective high in the air above. They were remarkably

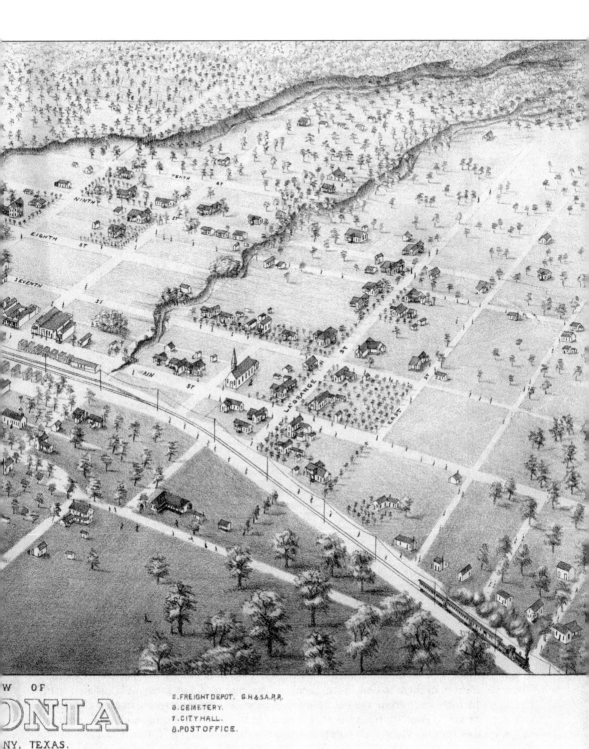

5.FREIGHT DEPOT. G.H&S.A.R.R.
6.CEMETERY.
7.CITY HALL.
8.POST OFFICE.

accurate, and this one has helped locate and date many of Flatonia's oldest structures, though the east- and westbound trains, both chugging away from town, strike a somewhat whimsical note. Fayette County has the distinction of being the only county in Texas to have all three of its largest towns depicted by these 19th-century artistic renderings. (EAAAM.)

13

Houston & Texas Central Railway

AND CONNECTIONS.

THE ONLY LINE RUNNING THROUGH THE CENTRAL AND BEST PORTIONS OF THE STATE OF TEXAS

Passenger Express Trains and Daily Fast Freight Lines

OVER THE ENTIRE ROAD.

ELEGANT · PULLMAN · PARLOR · CARS

ONLY ONES in the STATE, on all Day Trains between Houston and Denison.

Pullman Palace Sleeping Cars,

Each Way, Daily, Without Change, Between

NEW ORLEANS and ST. LOUIS, via HOUSTON, DALLAS and DENISON, GALVESTON and AUSTIN, via HOUSTON.

The SHORTEST LINE.

Between Texas, Kansas City, Hannibal and all points North and West, and Favorable Routes via Denison and Missouri Pacific Railway to Kansas City, Hannibal or St. Louis, or via the

G. H. & S. A. System All-Rail Through Line,

—VIA—

HOUSTON AND NEW ORLEANS

To all Points in the United States and Canada.

Via the last named Route the DAY EXPRESS TRAINS of the HOUSTON & TEXAS CENTRAL RAILWAY make DIRECT Connection in Union Depot, Houston, for NEW ORLEANS and all points in the South-east, North-east and East.

—o—

EUROPE!

Through Tickets from or to any point in Great Britain or Continent of Europe, via the HOUSTON & TEXAS CENTRAL RAILWAY, and all rail to New York, thence via NORTH GERMAN LLOYD, WHITE STAR, INMAN, STATE, ROTTERDAM and ITALIAN Steamship Lines, on sale at important Stations on line of this Railway, and at

GALVESTON,	CUERO,	VICTORIA,
SAN ANTONIO,	MARION,	SEGUIN,
WEIMAR,	LA GRANGE,	COLUMBUS,
FLATONIA,	SCHULENBURG,	SAN MARCOS,
ROUND ROCK,	NEW BRAUNFELS,	ROCKDALE.

☞ For information as to rates of passage and freight, routes, etc., apply in person or by letter to

DANL. RIPLEY,	A. FAULKNER,	J. WALDO,
G. F. A.	G. P. A.	Vice-Prest. and Traffic Manager

HOUSTON, TEXAS.

An 1860 letter by M.M. Sullivan describes a weeklong journey from Oso in Fayette County, Texas, to Verona, Mississippi—a torturous affair that involved travel by horseback to Alleyton in Colorado County, a train from there to Galveston, thence by steamer to Berwick Bay in Louisiana, again by train, which broke down in a mosquito-infested cane field before arriving in New Orleans, a connecting train to Pontchartrain, another steamer to Mobile in Alabama, and finally arriving by yet another train in Verona. By contrast, this advertisement in the *Historical and Descriptive Review of the Industries of San Antonio*, first printed by Land and Thompson in 1885 and later reprinted by Norman Brock in 1971, promotes the short routes and elegant accommodations of the Houston & Texas Central Railway. From Flatonia and other points along its line, the world was one's oyster, with connections to all points in the United States and Canada, as well as to ports in Great Britain or mainland Europe. (Len Waska.)

Flatonia agreed to pay $6,000 and construct a passenger depot as part of an 1887 deal to secure the route of the San Antonio & Aransas Pass Railway through town. This small depot was built where the new line crossed the older Galveston, Harrisburg & San Antonio Railway. Unfortunately, passengers desiring to change from one line to another had to negotiate the half mile that separated the two passenger stations. (Martha and Arnold Tauch.)

The San Antonio & Aransas Pass Railway freight depot, shown here in the background, sat next to the spur line that ran down the middle of Seventh Street just one block north of North Main Street. Both this depot and that of the Galveston, Harrisburg & San Antonio Railway sent and received mailbags such as that being handled by Frank Boehm, seen here around 1925. (EAAAM/ Audrey Simmons McWhirter.)

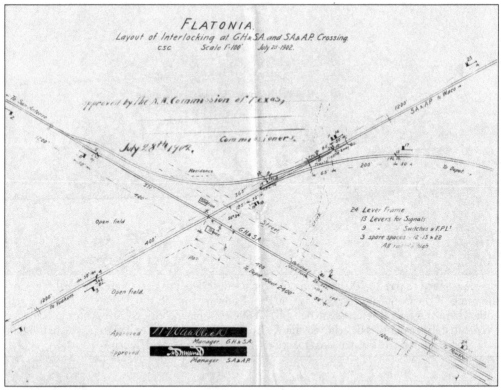

FLATONIA.
Layout of Interlocking at G.H.&S.A. and S.A.&A.P. Crossing
csc Scale 1"-100' July 28-1902.

24 Lever Frame
13 Levers for Signals
9 " Switches & F.P.L.
3 spare spaces - 12 -13 & 22
All round high

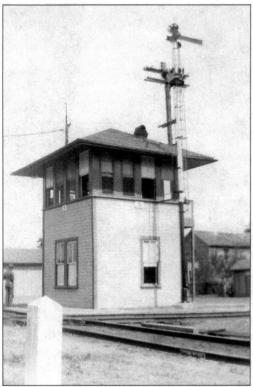

In 1902, the Galveston, Harrisburg & San Antonio Railway constructed a tower to control and switch trains at its intersection with the San Antonio & Aransas Pass line. The tower's complex mechanical interlocking system was designed to be manipulated entirely by human strength. The diagram above shows the original plan approved by the Texas Railroad Commission, with the tower seen at left completed that same year. Texas began its numbering system for rail switching towers in 1901 and Flatonia's was number three after that date. Tower 3 remained in active service until 1996, by which time it was the last of its kind still operating in Texas. (Above, Southern Methodist University - Degolyer Library; left, Martha and Arnold Tauch.)

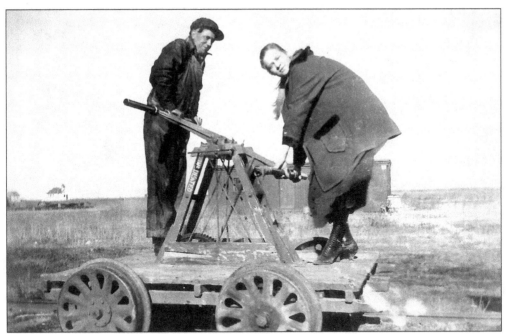

In the late 19th and early 20th centuries, handcars were used along sections of the railroad to inspect the line and take men and tools to sites requiring maintenance. An unidentified section hand looks on as Frieda Kurz tries the pumping mechanism that propelled the cars along the tracks. (EAAAM/Ella Tauch Sievers.)

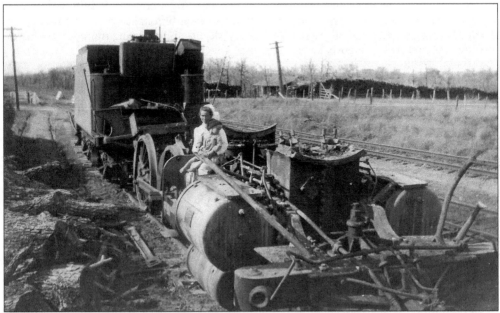

Inevitably, some rail accidents occurred in the vicinity of Flatonia. The worst disaster occurred on January 12, 1911, when a boiler exploded on an eastbound freight train one mile west of town, killing both the engineer and the fireman. Anna Tauch and her three-year-old son Arnold are seen here sitting on the remnants of the engine and its boiler following the tragedy. (EAAAM/ Ella Tauch Sievers.)

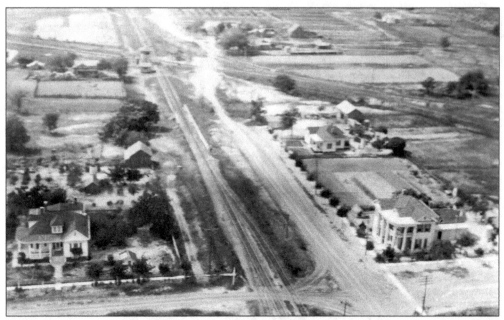

Air Corps veterans returning from service in World War I often gave rides in their Curtis JN-4 "Jenny" biplanes at country fairs and took aerial views of the towns over which they were flying. These photographs were taken during the Flatonia Fair of October 1918. The crossing of Flatonia's two rail lines just west of town and the 1902 switching tower near the junction can just be seen in the distance in the photograph above, with some of Flatonia's finest homes in the foreground. The photograph below, which first appeared in the *Flatonia Argus* on June 19, 1919, and shows a bit of the airplane's wing and struts, has a view that looks south from just over the buildings on North Main Street, past the railroad tracks, the two depots and a passing train, toward South Main Street and beyond. (Above, EAAAM/Jeanne Nikel; below, family of Dorothy Hudson.)

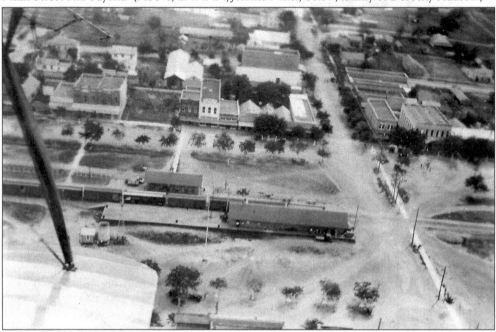

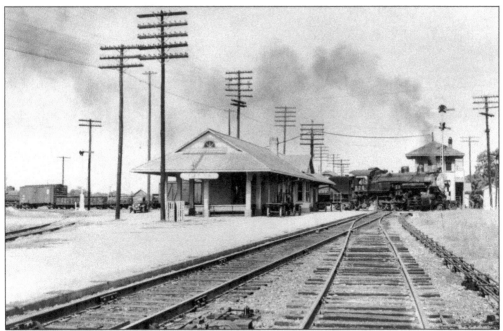

After years of public outcry for a "union" depot to serve both the Galveston, Harrisburg & San Antonio Railway and the San Antonio & Aransas Pass Railway, this handsome stucco building was finally erected in 1926. This photograph of a southbound freight at the crossroads also shows Tower 3 and some of the interlocking mechanism used to switch trains from one track to another. (Photograph by Philip R. Hastings, National Railroad Modeling Association Archives - Robert J. Macdonald Collection, permission from Riley Triggs.)

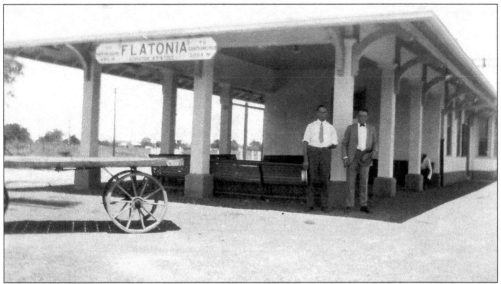

The overhead sign notes Flatonia's place on the Sunset Route: 482 miles to New Orleans, 2003 miles to San Francisco, elevation 454 feet. Arnold Tauch (left) was a signalman for Southern Pacific from 1927 to 1972. During World War II, his family home was a three-room boxcar that moved as needed between Houston and El Paso, but in 1946 his job brought him back to stay in his old hometown of Flatonia. (Martha and Arnold Tauch.)

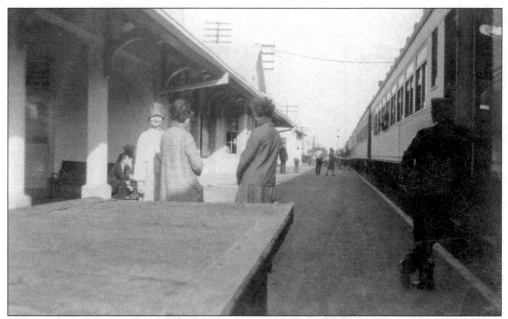

Passengers wait for the conductor (in shadow, far right) to give the "all aboard" signal at the new passenger station in Flatonia. Though the number of family owned automobiles was steadily increasing, roads were only beginning to be graveled, much less paved, so passenger rail service remained a popular option for travel of any distance through the 1920s and 1930s. (EAAAM/ Ella Tauch Sievers.)

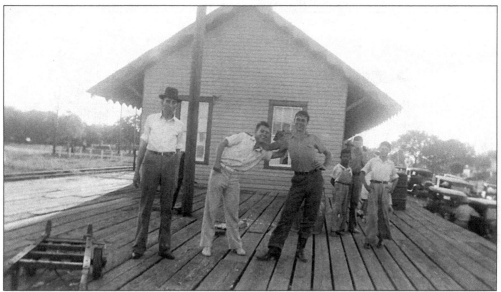

Even after the new passenger depot was constructed, this original 1874 freight depot continued in service until it was finally demolished in the 1950s. Standing at the center of town, the platform was the site of many gatherings through the years. A number of young men and boys mug for the camera on the platform in 1937 during one of Flatonia's Trade Days. (Family of Emily and G.T. Hawkes.)

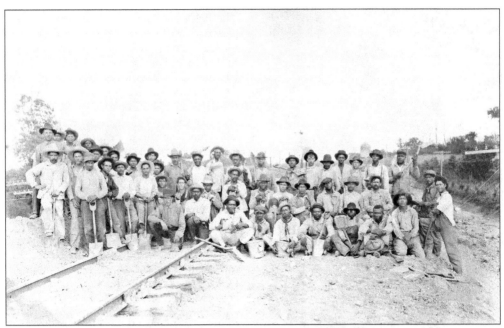

The railroad provided many jobs in Flatonia through the years. Section gangs, such as the one pictured above, were responsible for inspecting and maintaining the track, replacing ties and rails as necessary to keep the roadbed smooth and aligned. George T. Hawkes (back row, far left) came to Flatonia in 1928 as foreman for this section gang and oversaw the line from the crossroads east, halfway to Schulenburg, while Paul C. Zappe Sr. (right) was the foreman in charge of the tracks leading west from Flatonia. Zappe was employed by Southern Pacific from 1913 until his retirement in 1954. (Above, family of Emily and G.T. Hawkes; right, Jacqueline Robins Moncrief.)

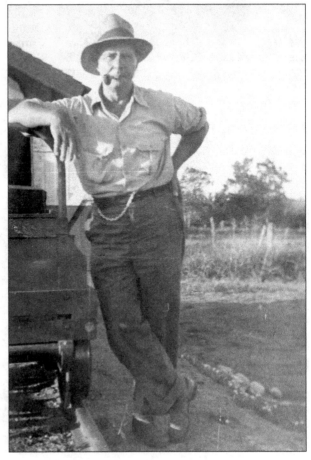

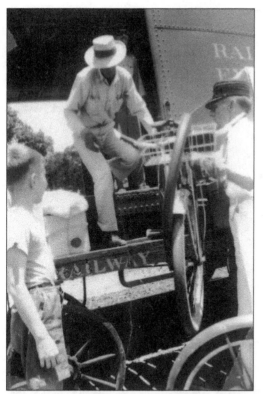

The 1940s saw a rapid decline in rail passenger traffic, but a great deal of industrial and personal freight continued to flow in and out of Flatonia. Frank Perry, left, and his brother Kirby (not shown) eagerly await delivery of their first bicycles at the depot in 1944. Their father, Methodist minister Vernon F. Perry, was serving as a US Army chaplain in Belgium when this photograph was taken. (Kirby Perry.)

School excursions by rail were uncommon by 1951 when these Flatonia schoolchildren and their chaperones boarded the train in neighboring Schulenburg for a trip to the Shrine Circus in Houston. The excited group includes, from left to right (first row) Walter Maeker, Dickie Dimici, Jimmy DeWitt, Becky Garbade, Ann Mueller, Peggy Mueller, and Max Steinhauser Jr.; (second row) Larry DeWitt, Dr. J.B. Cook, Kathryn Kolar, and Betty Mueller; (third row) Mary Ann Janak, Butch Janak, Eleanor DeWitt, Carolyn Janak, Frances Garbade, Eula Brown, and Sammy Brown. (Family of Frances and Lonnie Garbade Sr.)

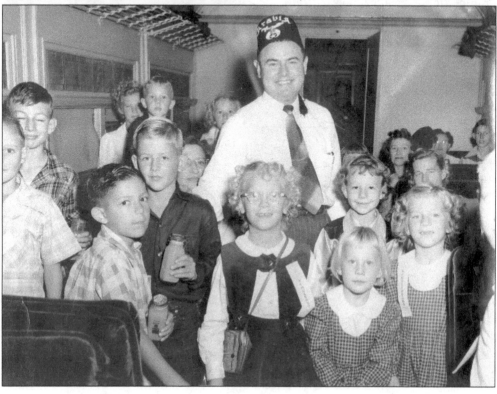

Two

LET'S DO BUSINESS

Early photographs of Flatonia show a bustling, vibrant business district. Situated in the middle of a large trading area, Flatonia was an important shipping point for Fayette, Lavaca, and Gonzales Counties. Little more than a decade after the town was established, it reported exports of 17,650 bales of cotton, 58,300 bales of wool, 132,000 pounds of hides, 1,300 tons of cottonseed, and 222 cars of livestock in one season. An article in the *Galveston Daily News*, September 1, 1886, goes on to say, "the town claims an annual trade approximating $1,000,000, with every indication in the way of territory, large and complete stocks of merchandise and enterprise of business men to justify these claims."

In these heady early days, it looked like Flatonia would grow to be a considerable city. It was, however, soon surrounded by trading centers of a similar size. Its population and trade revenues actually declined for a time before commencing to rise again at a more sustainable pace.

It was to Flatonia's great good fortune that its businessmen have always been a tenacious lot. Just as they had banded together to bring a second rail line through Flatonia, they also ensured the routing of a major coast-to-coast highway along North Main Street through the heart of the downtown business district. As rail travel and shipping waned, automobile travel and trucking rose to take its place. Just as the railroad had served in the past, the new highway system would continue to provide the infrastructure needed for survival in changing times.

Two world wars and the Great Depression all had their impact on the ebb and flow of commerce in Flatonia. People have come and gone, businesses have opened and closed, but the images that follow record some of the faces and scenes from times gone by and a spirit that endures for future generations.

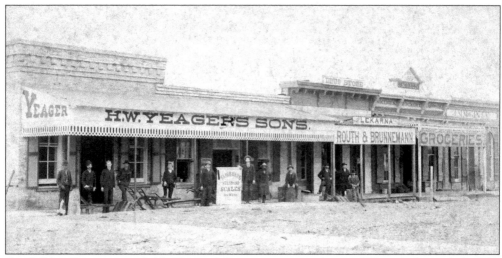

South Penn Street was probably Flatonia's busiest commercial street following the arrival of the railroad. H.W. Yeager's Sons occupied two buildings seen at the far left in this photograph from about 1890. Of this pair of Yeager buildings, the one on the right side was the first rock building in the business district. Known as the Centennial Building, it was constructed in 1876 of locally quarried sandstone. (Southern Methodist University - DeGolyer Library, Lawrence T. Jones III Photography Collection.)

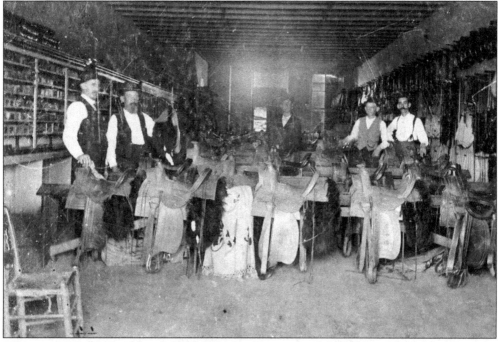

Christian Stoffers (second from left) built the first two-story rock building on North Main Street in 1879 for his thriving harness and saddle business. Stoffers sold the building to the newly organized Flatonia Bank in 1909. First the Masons and then the Knights of Pythias met in the meeting hall upstairs, but the Southwestern Bell Telephone switchboard occupied the second-floor space from 1910 until 1927, when both the bank and the telephone office moved to a new building on the corner of North Main and Penn Streets. (Louis Hoffman.)

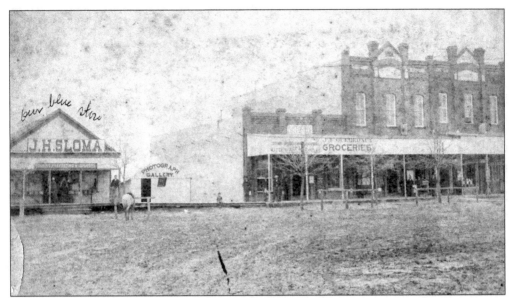

The photograph gallery seen here on South Main Street in 1890 was a short-lived enterprise. Flanked by the J.H. Sloma "Blue Store" on the left and the First National Bank of Flatonia on the right, the lot left vacant by its removal served, beginning in 1912, as the Air Dome—an open-air venue where the Happy Hour Theatre showed its films during the hot summer months. (Family of Honora Sloma Paul.)

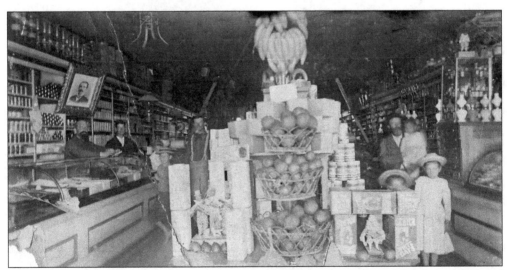

The J.H. Sloma store advertised Deering Harvesting Machinery on its awning, but it displayed a variety of merchandise indoors. Thanks to daily deliveries by rail, exotic produce like bananas from the stem and fresh coconuts were readily available in 19th-century Flatonia. Pictured in 1893 are, from left to right, J.H. Sloma, Albert Strahle, Ed Berger, John Sloma, two Greenshield girls, and behind them, a Mr. Mays holding Honora Sloma. (Family of Honora Sloma Paul.)

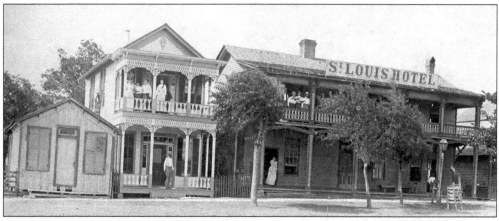

The St. Louis Hotel was owned by J.A. Cadwell and managed by Letitia M. Snell. It dated from Flatonia's earliest days and was reputed to offer some of the finest accommodations on the railroad's Sunset Route. An 1879 advertisement in the *Flatonia Argus* touts "large comfortable rooms with or without stoves. Clean beds, the table supplied with the best the market affords. Accommodating porters, baggage taken to and from the depot free of charge." (Kathryn Cooper.)

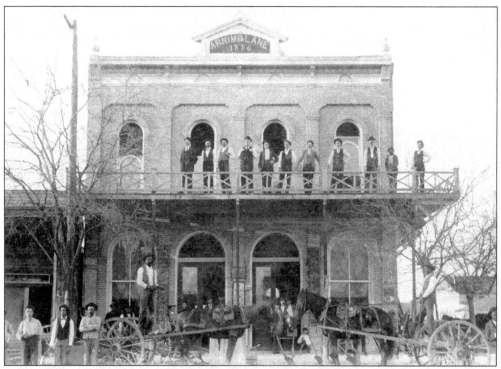

E.A. Arnim and Jonathan Lane built this prominent Flatonia mercantile store in 1886 and though Lane later left the retail business to become a highly regarded attorney, Texas state senator, and judge, the partnership endured under Arnim's management. The building's top floor served as an elegant opera house until 1896. The ground floor was dedicated to general merchandise and operated continuously under just two generations of Arnims until 2001. (EAAAM/Ann and E.A. "Sam" Arnim.)

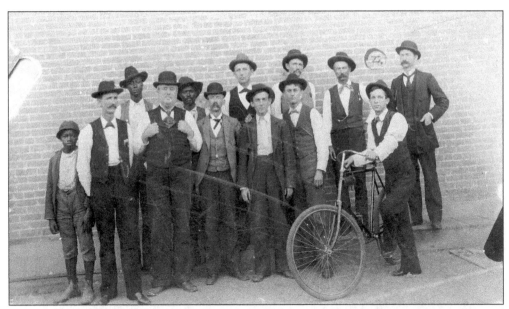

The Arnim & Lane opera house had closed when this photograph was taken in 1897, but the retail business continued to be an unqualified success, selling everything from buggies to buttons. The employees of 1897 are identified by first or last name only in Arnim's own handwriting: from left to right, Max, Joe, Dick, Arbuckle, Qucay, Thatcher, Kubena, Walker, Austin, Dusek, Menefee, Lane, and Arnim (though the Lane pictured is not founding partner Jonathan Lane). It was not until 1889 that Flatonia's mercantile stores first employed women as clerks. The photograph below shows the female employees of the Arnim & Lane store in about 1915: from left to right, Anita Kubena, Eula Sullivan, Mildred Fox McKay, and Della Johnson. (Above, George Koudelka; below, Billie Grace Herring.)

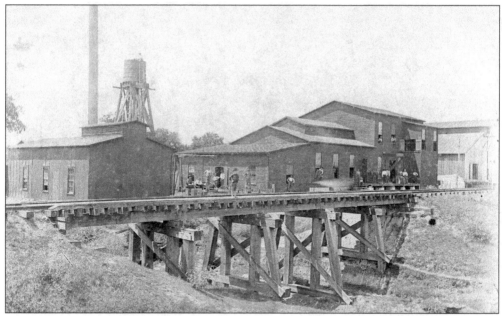

The Flatonia Oil Company, chartered in 1892, was the first of several small industrial plants to be established alongside the Seventh Street railroad spur. This mill turned the cottonseeds left after ginning into a valuable commodity. The process extracted high-quality oil from roasted seeds for use in soaps, lubricants, and food products. Wasting nothing, the crushed seeds were then pressed into cakes for animal feed. (EAAAM/Ann and E.A. "Sam" Arnim.)

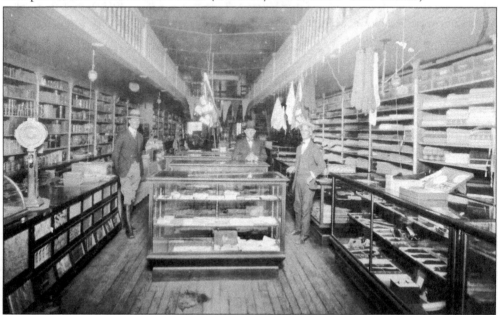

J.M. Harrison and C.J. Lane moved their mercantile business from Oso to Flatonia with the coming of the railroad. With Lane's departure in 1883, the business was reorganized as Harrison & Arnim, until Arnim also left to build his own store. Then renamed J.M. Harrison & Sons, it is seen here in about 1910 with, from left to right, Henry H. Harrison, J.M. Harrison, and C.P. Harrison Sr. (Family of John Moffett Harrison.)

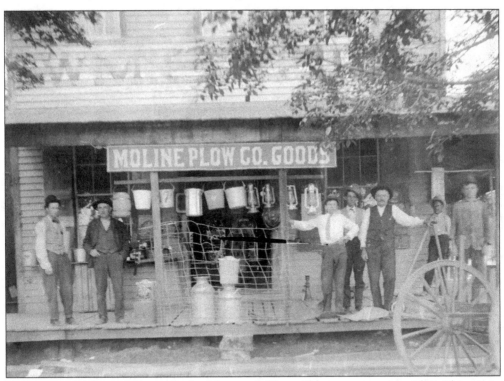

William Stein (above photograph, third from right) began his career as a tinsmith in Flatonia in 1882, moving into this building on the corner of South Main and Penn Streets in about 1888. Specializing in tin cisterns, windmills, metal roofing, cookstoves, and heaters, it would become the most popular hardware store in town. The frame building seen here in both photographs from the late 1890s or early 1900s was replaced by a new tin-clad building on the same lot in 1915. William Stein's son, Hugo Stein Sr., continued to operate this business well into the 1970s. (Above, Hugo Stein Jr.; below, EAAAM/Betty and W.W. "Sweet" Mueller.)

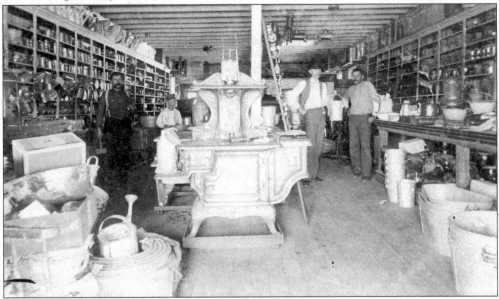

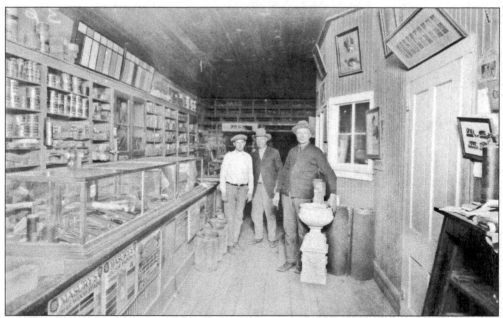

The Flatonia Lumber Company was incorporated in 1907. For many decades, this lumber company on North Main Street was the go-to place for building needs—for professional contractors and do-it-yourselfers alike. Its business grew over the years and this original frame building, shown here with longtime manager A.W. Albrecht (right) and two unidentified customers, was replaced in 1929 by a brick structure that doubled its space. (EAAAM/Ann and E.A. "Sam" Arnim.)

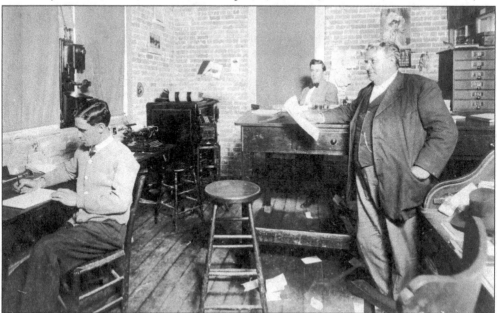

Cowdin Wholesale Grocery was recognized as one of Flatonia's leading commercial successes. It employed several salesmen who covered a considerable trade territory. A direct coffee importer, the company roasted up to 5,000 pounds of beans every Friday. Founder and president E.G. Cowdin (far right, in this 1911 photograph) was also president and the driving force of the Flatonia Committee, an organization dedicated to the town's economic development. (EAAAM/Cowdin family.)

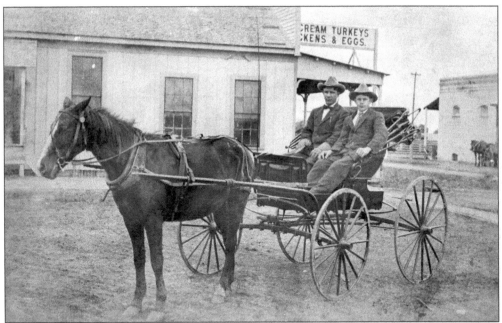

R.E. Boe, standing at far right in the photograph below, was a Danish-born and German-trained dairy specialist who established the Flatonia Creamery in 1908. Pictured in these two photographs from about 1911, the creamery shipped an average of 25,000 pounds of butter every month and was the second-largest producer in the state. Boe later recalled one particularly hectic day in which the plant processed a 400-pound special order for a Houston convention, and the hair-raising maneuver it took to get it there. With the butter churned, chilled, and packed with no time to spare, the creamery's delivery wagon shot across the tracks a mere 50 feet ahead of the oncoming freight's locomotive. Despite the close call, the load was transferred into a railcar just in the nick of time and the hotel had its fresh butter for the evening meal. (Both, Juanita Nikel.)

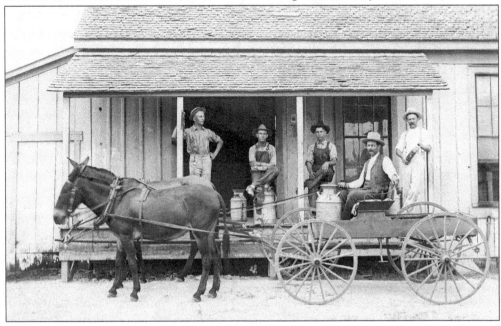

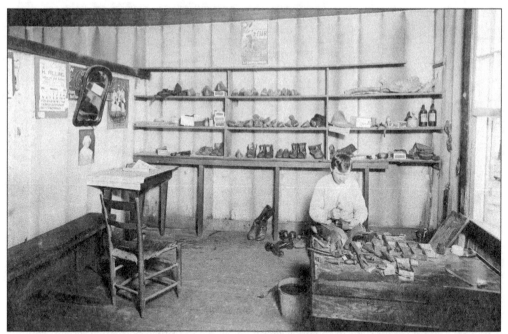

Joe Prihoda is shown at his shoe repair business on South Main Street in this 1911 photograph. In the 1916 Flatonia Fair program, Prihoda advertises the "Frieman and Shelby Line of Ladies' and Gents' Shoes" in addition to expert repairs. In 1929, he had contractor William Ungerer construct a brick building with large plate-glass windows to house his shop. (Carl Prihoda.)

J.D. Chalk, blacksmith and wheelwright welcomed all kinds of blacksmithing and buggy repair work in his shop on South Penn Street. His weekly advertisement in the *Flatonia Argus* declared, "Your horse's feet fare better when shod by one who knows how. I claim to be an expert in this line." When this photograph was taken in 1911, Chalk still had plenty of business doing such work before the automobile entirely dominated personal transportation. (EAAAM/Ann and E.A. "Sam" Arnim.)

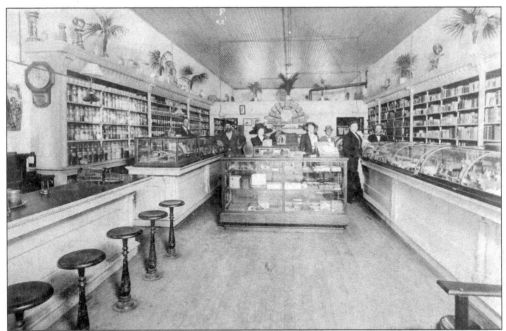

For many years, Flatonia was home to several drugstores at any given time. The photograph above shows the Gosch Drug Store as it was in 1911, shortly before A.M. Gosch became postmaster and sold out to Ed Mikulik. By the 1940s, Mikulik's Drug Store had become a stop for buses traveling along Highway 90. Both it and the Daehne Drug Store, below, were famous for their popular soda fountains. Doctors were frequently associated with particular drugstores and had offices on the premises. Seen in this photograph from about 1929 are, from left to right, Harold Foitik, Dr. Frank Marecic, and pharmacists Allen and Frank Daehne. (Above, EAAAM/Jean and Barney Wotipka; below, family of Frances and Lonnie Garbade Sr.)

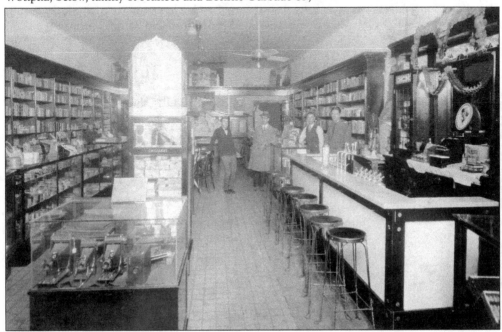

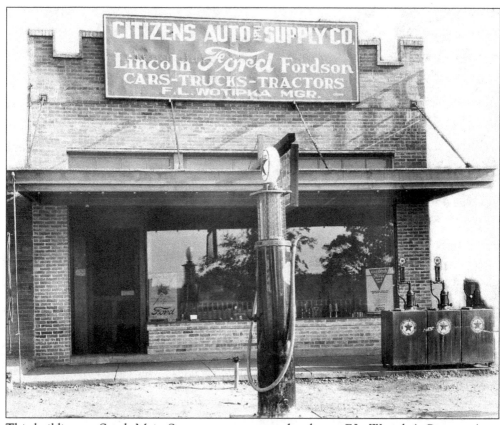

This building on South Main Street was constructed to house F.L. Wotipka's Citizens Auto Supply Company in 1920. Brand-new Ford cars and Fordson tractors were sold out of the tidy front showroom. Ford sales soon outgrew these quarters, and in less than five years the dealership moved across town to North Main Street. (Both, EAAAM/Jean and Barney Wotipka.)

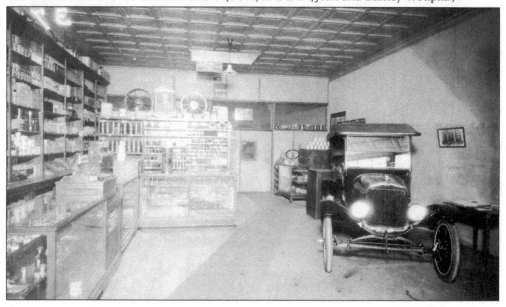

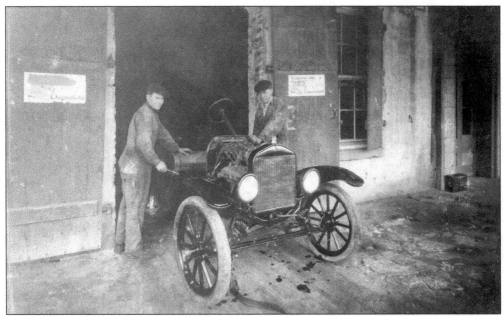

Early Model Ts came with "some assembly required." Two unidentified mechanics are seen here in the doorway of a building on South Penn Street as they put the final touches on a new Ford. The exact year of the photograph is unknown, but a Chesterfield Cigarette advertisement such as the one on the right-hand door is known to have been in circulation in 1924. (EAAAM/Jean and Barney Wotipka.)

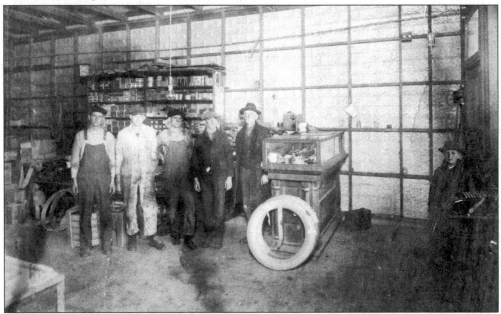

While Fords enjoyed a large share of the Flatonia automobile market, Chevrolets were popular too. According to the *Flatonia Argus* of November 15, 1923, Lee and Vogt Chevrolet dealership and garage received and distributed a shipment of 53 Chevrolet cars in a single month. Pictured in the garage at about that time are, from left to right, Ed Grubbe, Herbert Agricola, Henry Niemann, Eddie Zouzalik, O.L. Lee, and Ira Syler. (EAAAM/Ann and E.A. "Sam" Arnim.)

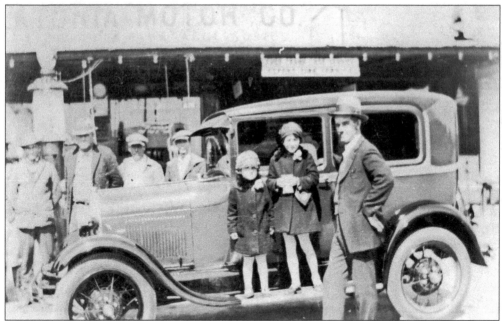

When F.L. Wotipka moved his Ford Dealership across the tracks to North Main Street in 1924, he began doing business under the name Flatonia Motor Company. The photograph above shows Frank Cowdin and his daughters taking delivery of the first Ford Model A to reach Flatonia in about 1928. Below, a banner across the doorway of the same dealership advertises the arrival of 1953 Ford economy trucks. F.L. Wotipka's son, Barney Wotipka, took over the Flatonia Motor Company in the 1950s and continued to operate the dealership and garage until 1981, when he closed it after celebrating 60 years of Ford service in Flatonia. (Both, EAAAM/Jean and Barney Wotipka.)

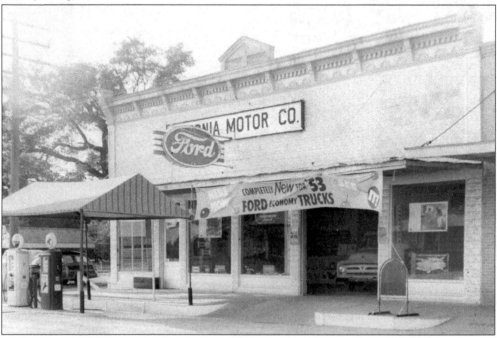

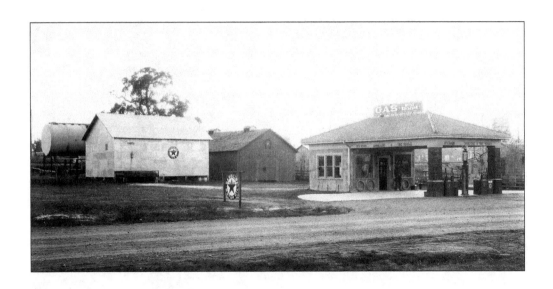

The Old Spanish Trail was a named tourist highway that would eventually be completed from coast to coast. The exact route it would take through Texas was contested by other towns and remained uncertain for a time, but by the 1920s Flatonia's position on the highway was firmly established. The traffic derived from this thoroughfare led to an increase in automobile-related businesses through town. Filling stations such as the Wotipka brothers' Texaco station (above) were built on the approaches to the business district. Gasoline, water for radiators, air for tires, restrooms, and cold drinks invited travelers to stop—and when they stopped, it was good for the local economy. Eddie Zouzalik (below) also offered cabins for overnight accommodations in the Flatonia Tourist Park, later known as the Palace Courts, Flatonia's first motel. (Above, EAAAM/ Jean and Barney Wotipka; below, family of Frances and Lonnie Garbade Sr.)

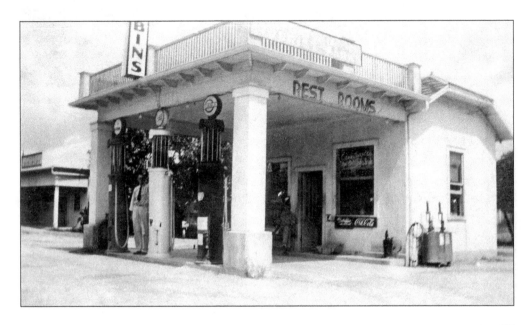

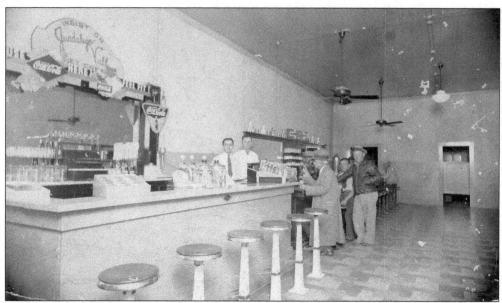

Local citizens regularly patronized cafés along North Main Street, but these popular eateries also attracted tourists traveling the Old Spanish Trail, which later became US Highway 90. Long before fast-food establishments homogenized the offerings across the country, family-owned cafés were reliable sources for reasonably priced home-style cooking. Felix Brunner and his ever-popular City Cafe served generations of satisfied customers. Pictured behind the counter in the above photograph are, from left to right, Frank Novak and Felix Brunner. In the photograph below, Charlie Polasek stands by the pinball machine in his café at the Polasek Hotel, also known for a time as the Castle Inn. In 1936, it advertised free dances every Friday night with music by the Cistern Orchestra. Polasek eventually opened a wayside travel stop called Whistleville several miles west of Flatonia on Highway 90. (Above, Dennis Brunner; below, Juanita Nikel.)

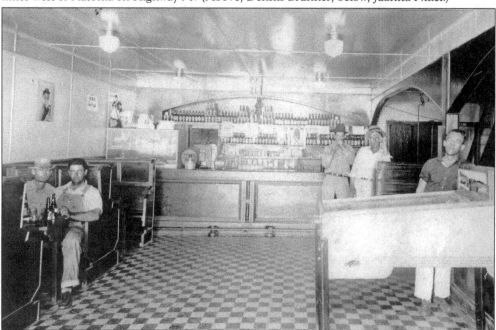

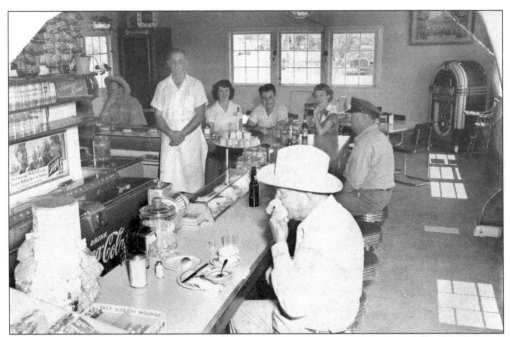

The Bluebonnet Cafe was another popular gathering place on Highway 90, just west of the railroad underpass. Louis Brunner, seen here behind the counter in this photograph from the 1950s, was well known for his short-order cooking skills at both the City Cafe and the Bluebonnet before becoming chief cook and manager of the Flatonia Public School cafeteria. (Janice Brunner Stried.)

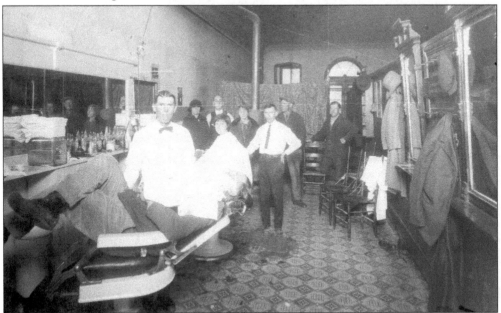

While cafés were great places to catch up on local happenings, the next best place to gather news of the day was a barbershop or beauty salon. John J. Rollig's Tonsorial Parlor on South Main Street served both men and women, as can be seen in this photograph from early 1930. Barber and proprietor Rollig is standing just right of the stovepipe in white shirt and tie. (Family of Margaret and A.J. "Duke" Freytag.)

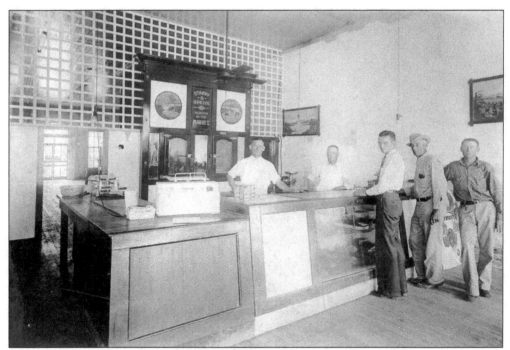

R. Henry Greive (left) and Jim Starry are standing behind the counter in this photograph from the 1930s. They owned and operated Starry and Greive's North Side Market, one of the most highly regarded meat markets in town. (Vyvjala and Greive families.)

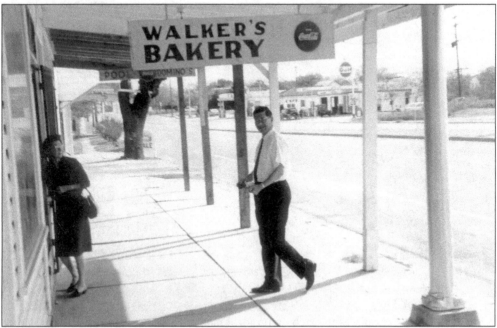

In this photograph from the 1960s, customers are entering Walker's Bakery at the east end of North Main Street. R.J. Walla had a bakery on this site from the 1890s. When the building was destroyed by fire in the 1990s, it was discovered that the oven had been made of local bricks with the imprint of F.W. Flato's 19th-century brick factory. (EAAAM/Rolla Mueller.)

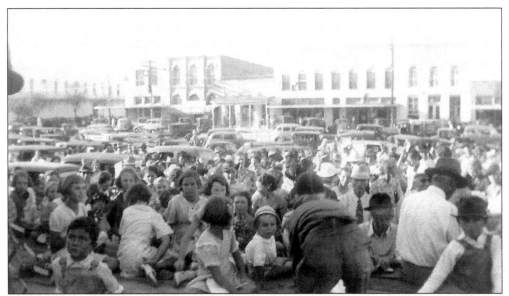

While still in the grip of the Great Depression, Flatonia merchants hosted Trade Days, featuring store specials, prizes, street dances, and other entertainments to attract customers. Every such event would help alleviate the hard times and, as seen in this photograph from 1937, crowds of people and automobiles fill the open space between the railroad tracks and North Main Street. (Family of Emily and G.T. Hawkes.)

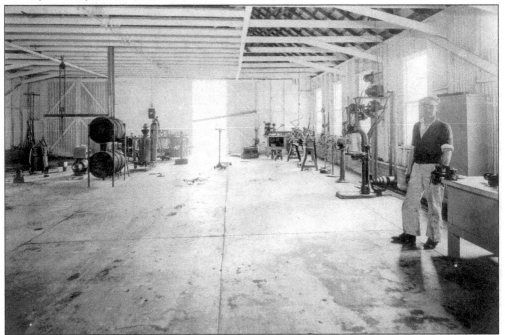

Machine shops like this one on South Penn Street replaced the blacksmith shops of earlier days. Seen here in 1938, Freytag Garage and Machine Shop owner and operator Allen "Duke" Freytag was an expert welder and machinist who could repair or custom make almost any part made of metal. At his gun bench and lathe, he repaired, built, and rebuilt rifles and handguns. (Family of Margaret and A.J. "Duke" Freytag.)

Home deliveries used to be very common for all manner of goods and services. George Simmons, far left, stands next to a delivery truck for Simmons Produce, while a few of his employees display some of his wares, including fresh fish and watermelons. Note the two-digit phone number, which remained in use until the mid-1950s. (EAAAM/Audrey Simmons McWhirter.)

Several small industries in Flatonia altered their usual production to support wartime needs. Southern Produce hired staff, including many young war brides, specifically to crack eggs. They filled five-gallon containers with the eggs, which were then scrambled, frozen, and shipped to military bases. Workers pictured in about 1944 are, from left to right, (first row) Stella Wotipka, Lorene Cowan, Mary Schoenweitz, Albina Stewart, Ella Mica, Elsie Dornak, Kate Brunner, and unidentified; (second row) Millie Mica, Gladys Fishbeck, two unidentified, Nita Zemlicka, Della Ballard, and Mary Hobizal; (third row) Edward F. Mueller, Felix Mica, Major McCoy, Jim Zapalac, Adolph "Junior" Schacherl, and unidentified. (EAAAM/William Hobizal.)

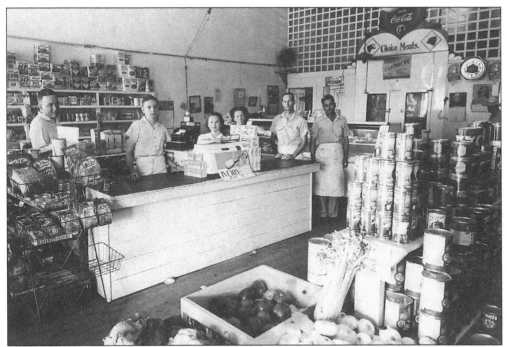

In the 1940s, Joe Grieve opened the City Market grocery store in what was formerly the Southside Market. Seen above in about 1948 are, from left to right, Joe Grieve, Vendeline Pospisil, Wanda Sue Null, Rose Beale, Paul Beale, and Willie Brosch. Grocery stores took special pride in their meat markets, and usually had a barbecue pit out back for drive-through pickups of brisket, ribs, and housemade sausage. Pitmasters Earnest (left) and Willie Lee Williams are shown below at the City Market pit in the 1960s preparing for the usual Saturday noon rush. The Williams cousins were both butchers and worked in this business for almost 50 years, taking pride in helping people pick out the exact piece of barbecued meat they wanted for their weekend meals. (Above, Sandy Grieve Krause; below, Earline Williams.)

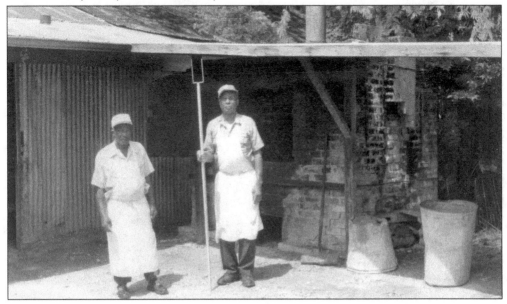

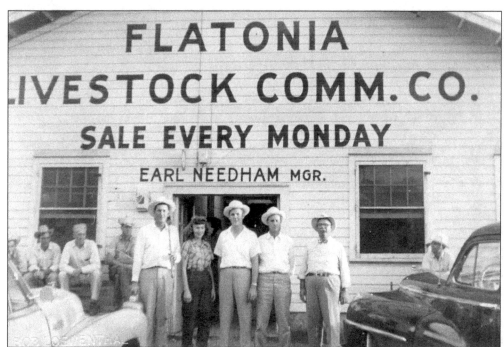

Earl Needham opened the Flatonia Livestock Commission Company in 1948. In the very first sale held on Monday, April 5, a total of $86,000 in sales of cattle, hogs, sheep, and horses changed hands. There has been a sale almost every Monday since, rain or shine, bringing buyers from near and far and establishing Flatonia as one of the busiest livestock markets in south central Texas. Seen in the photograph above, standing from left to right, are owner and manager Earl Needham, bookkeeper Sally Bigley, auctioneers Waylon and Garlan Houck, and a Mr. Parley of the Blue Ribbon Packing Company in Houston. In the photograph below, local cowboys wait in line to unload their cattle for a Monday auction. (Both, Ginny Needham Sears.)

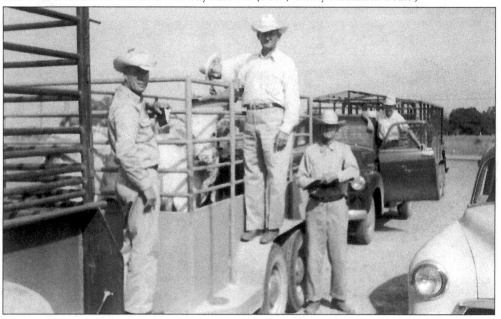

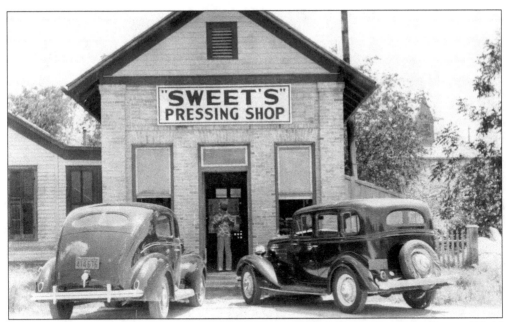

While a number of returning servicemen left Flatonia to pursue careers elsewhere following World War II, others came back to open their own businesses and raise families in their old hometown. W.W. "Sweet" Mueller opened Sweet's Pressing Shop in this neat building on South Main but later moved to a building on North Main. He eventually left the dry cleaning business to become the town's postmaster. (Peggy Mueller.)

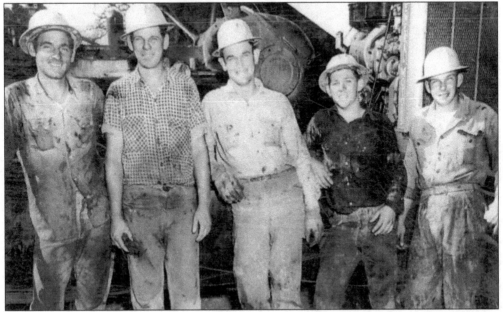

The area around Flatonia has experienced many a boom and bust in the oil business, beginning as early as 1901 when waves of exploration and drilling spread outward from Beaumont following the Spindletop gusher. These young men found work in the industry in the 1950s, employed by Sutton Drilling Company. They are, from left to right, George Koricanek, Ed Votaw, Willie Mica, "Bedpost" Smith, and Marvin Brunner. (Marvin Brunner.)

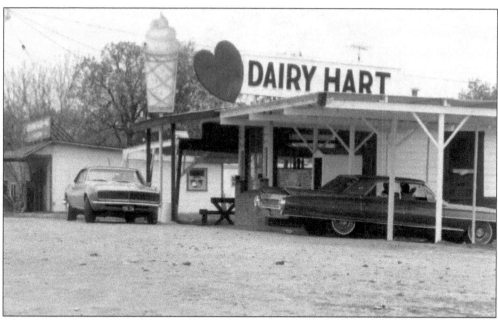

Glyn and Velma Johnson moved a building to the site of the burned-out Red Top Inn in 1956. Called the Dairy Hart, it quickly became the most popular teen hangout in town. Milkshakes, sundaes, frosted drinks, 20¢ hamburgers, nickel root beers, custard cones, and, last but not least, the famous "dooper dogs" were veritable magnets for school lunch money and allowances. Its iconic red "hart" is seen here in 1968. (EAAAM/Rolla Mueller.)

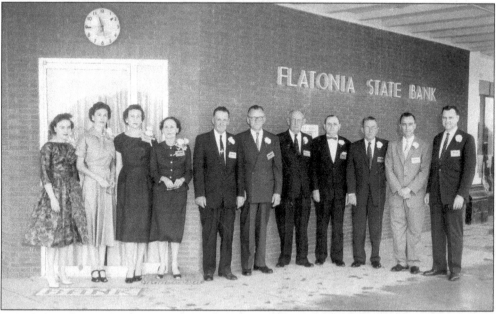

The Flatonia State Bank marked its 50th anniversary in 1959 with a grand celebration. Posing in front of the newly remodeled building, the bank employees and members of the board of directors are, from left to right, Maxine Nikel Vyvjala, Jeanne Nikel, Ruby Mueller, Lydia Freytag, Max Freytag, Felix Brunner, D. Faye Johnson, R.D. Zapalac, George F. McWhirter, Barney Wotipka, and Edwin Zapalac. (EAAAM/Jeanne Nikel.)

Three

PUBLIC WORKS

As trade prospered, the good citizens of Flatonia did more than just promote their private commercial interests to make the town more attractive and improve the quality of life. Public works and public service were required to build the infrastructure of a growing community.

Sidewalks were added to keep pedestrians out of the mud, roadways were improved and maintained, trees were planted to shade the main shopping streets, and city ordinances were passed to keep livestock out of the business district.

Over the years, law enforcement facilities, electricity, telephone service, a public water supply, a sewer system, and a firefighting brigade were established to serve and protect the population. Civic organizations, such as the Flatonia Committee, the Flatonia Chamber of Commerce, and the Jaycees would form to boost the town and make it a better place to live. Service organizations such as the Masons, the Knights of Pythias, Odd Fellows, Woodmen of the World, the Rotary Club, and the Lions Club all played their roles in Flatonia's economic and social development, and though some are now defunct, the Masons, the Rotarians, the Lions, and several other civic groups are still active and contributing to the community today.

Flatonia came of age in the late 19th century and fortunes would ebb and flow into the 20th century, but there were always men and women committed to work for what they believed would benefit the community as a whole. With all the changes in and around it, Flatonia would never lose its sense of identity and its own unique pride of place.

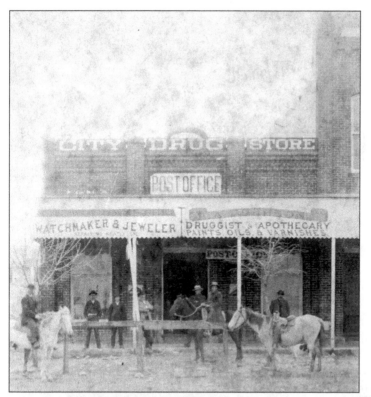

Postal service is vital to any community's interests, and this was especially so in the late 19th and early 20th centuries, when other means of communication were limited. This building was erected in 1880, housing the City Drug Store and a watchmaker/jeweler as well as the post office. By 1890, the post office had moved and the Flatonia National Bank opened here as the first brick-and-mortar bank in town. (EAAAM/Betty and W.W. "Sweet" Mueller.)

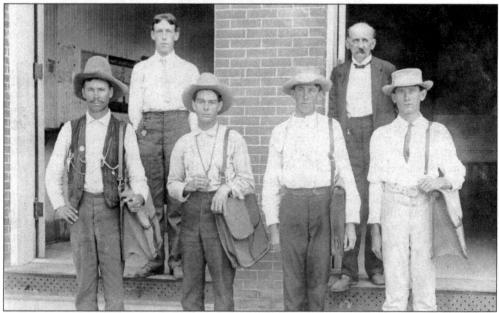

A new redbrick post office was built on South Main Street in 1901. The carriers for the four rural routes are seen here around 1908, about the time when rural free delivery began in the Flatonia area. From left to right are (first row) Harry Wiedemann, Frank Pechacek, Herman Schutz, and Harry Foitik; (second row) assistant postmaster Fred Laux and his father, postmaster Julius Laux. (EAAAM/Jeanne Nikel.)

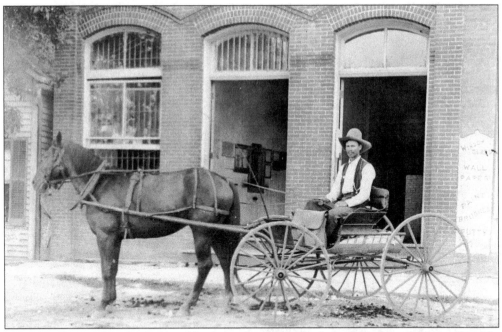

Harry Wiedemann has the day's mail loaded on his rig and ready to depart from the post office. His route would take him over miles of rough roads south of Flatonia, to scattered farmhouses where he might be the only person, outside of family, seen for days or even weeks on end. Checking the mailbox was the highlight of many a farm family's day. (Wiedemann family.)

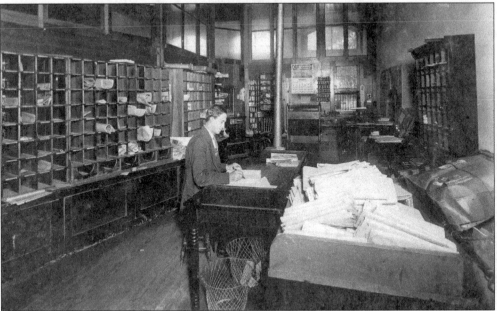

Fred Laux succeeded his father, Julius, as Flatonia's postmaster (both pictured on the preceding page), followed by A.M. Gosch in 1913. Gosch sold his drugstore to accept the position and is seen here working at his desk behind the bank of postal boxes. A calendar on the rear wall dates the photograph to November 1913, just months after his appointment in May of that year. (EAAAM/ Jean and Barney Wotipka.)

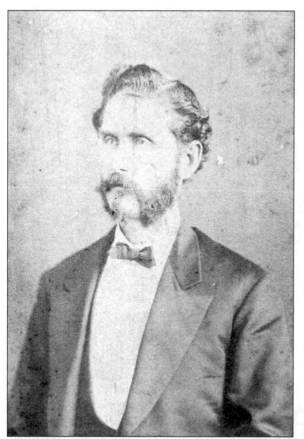

William A. Faires had the original land grant on which Flatonia was located. Pictured here is his son, R.O. Faires, one of Flatonia's most distinguished citizens in its formative years. Having already served as Fayette County sheriff, Faires served as Flatonia's city engineer, alderman, and city attorney and was in his fourth elected term as mayor when he died suddenly in office in 1898. (Barkley Thompson.)

A justice of the peace courthouse was built in 1888 to serve the demands of law and order. A railing in the courtroom separated spectators from attorneys and jurors, a matter of practical necessity in 19th-century Flatonia, when fights might break out at any time. The rooftop bell called citizens to court and served as the town's fire alarm. The Masonic Lodge owns the building and has met here continuously since 1888. (Vyvjala and Greive families.)

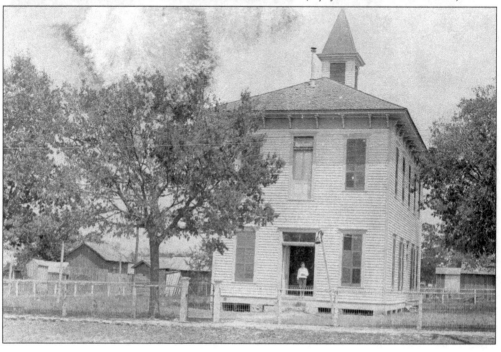

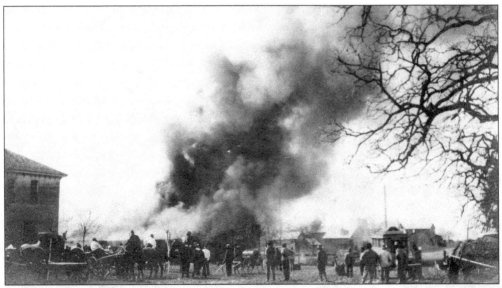

Several fires changed the look of Flatonia over the years. In the 19th century, ill-equipped hook-and-ladder clubs had limited success in fighting such conflagrations. In this photograph from the 1890s, smoke billows from a fire in the southeast quadrant of the business district as spectators gather to watch. (EAAAM/Kate Lyon.)

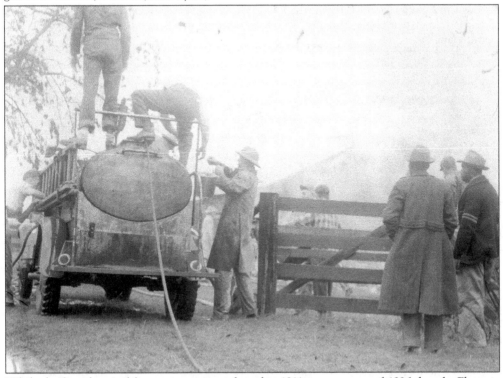

While the first chemical fire engine was purchased in 1911, it was not until 1926 that the Flatonia Volunteer Fire Department was officially established under the leadership of its first fire chief, Alfonse L. Vrana. This photograph shows a tanker truck and volunteer firemen turned out to fight a hay barn fire in the 1950s. (EAAAM/ Frank Marcie.)

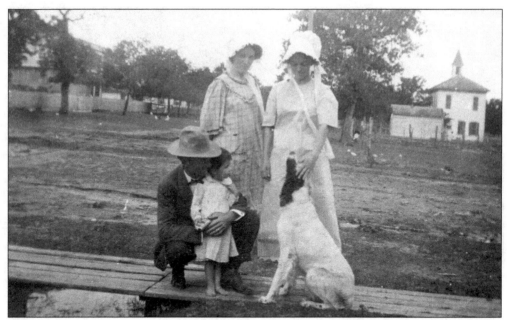

Well into the 20th century, basic community infrastructures were often wanting. Store owners often had to construct their own sidewalks. Narrow plank sidewalks were the only means of getting across town in wet weather without trudging through ankle-deep mud. The unidentified pedestrians and their dog in this photograph are keeping mud-free on the boards. (EAAAM/ Cowdin family.)

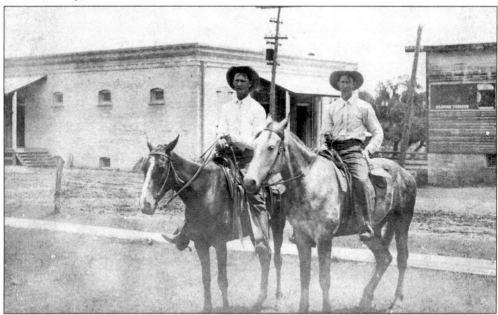

When this photograph was taken around 1908, unpaved roads became quagmires in muddy weather and had yet to be improved. It would not, however, be long before citizens called for more and more gravel roads. Eventually, hitching posts gave way to parking spaces on Flatonia's streets and cowboys like Julius and Emil Vybiral, seen here on Market Street, had to learn to share the road with automobiles. (Juanita Nikel.)

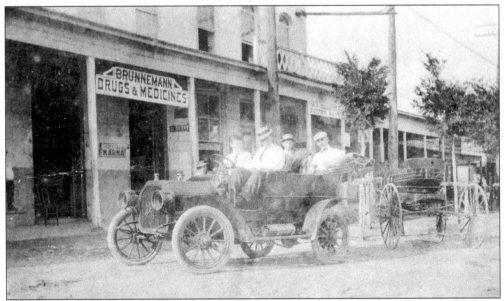

In 1909, Richard Wheeler bought Flatonia's (and Fayette County's) first automobile and promptly took delivery of three more as a dealer—to the chagrin of anyone whose only form of horsepower was an actual quadruped, which, unfortunately, tended to shy at these newfangled conveyances. This photograph of a 1909 Buick and several unidentified men in front of Brunnemann's Drug Store shows one of these harbingers of change that would soon transform the way people lived and worked. (Jon Todd Koenig.)

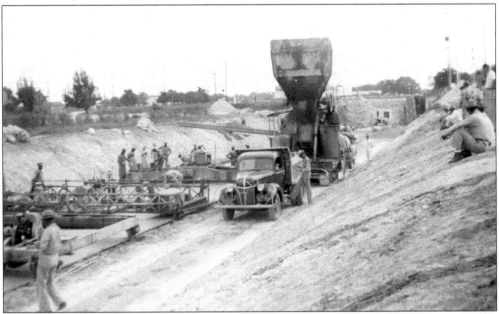

With an eye to ensuring rapid troop deployment, the federal government stepped up its paving of transcontinental highways. The Flatonia Chamber of Commerce was successful in its bid to preserve the path of US Highway 90 through the business district. This 1941 photograph shows the paving and construction at the site of a new underpass that would take the roadway under the rail tracks on the west side of town. (EAAAM/Anita and Max Steinhauser Sr.)

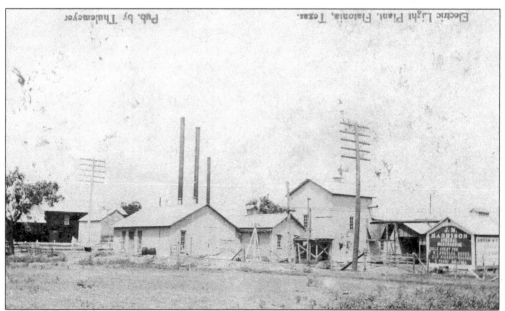

Before the Flatonia Ice, Water, and Electric Company came on line in 1911, electricity was intermittently supplied by one or another of the cotton gins in town. This photograph of the Kristek cotton gin dates from about 1906 and is labeled "Electric Light Plant, Flatonia, Texas." (EAAAM/Betty and W.W. "Sweet" Mueller.)

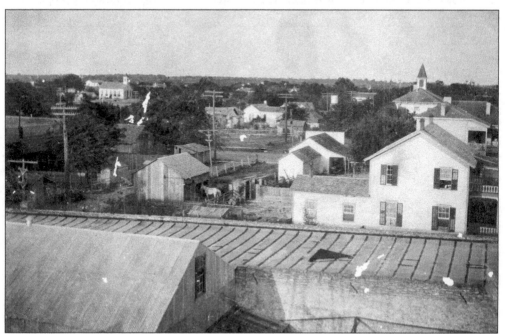

Until a bond issue for a citywide water and sewage system was passed in 1926, every home and business was on its own. A careful inspection of this view looking east from a rooftop at the corner of Sixth and Penn Streets reveals an outhouse in the backyard of a house located at the edge of the business district, as well as windmills and cisterns on many of the properties. (Jon Todd Koenig.)

Representing the latest in modern health services, the City Hospital occupied the wide building on the right from its construction in 1897 through about 1905. A rooftop cistern and windmill provided the hospital's water supply, but they were removed in 1914 when the top floor began to be used as an opera house. The Wheeler Building on the left housed a dentist's office above a ground-floor clothing store. (Family of Margaret and A.J. "Duke" Freytag.)

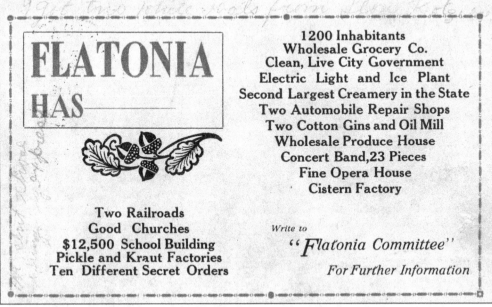

FLATONIA HAS

1200 Inhabitants
Wholesale Grocery Co.
Clean, Live City Government
Electric Light and Ice Plant
Second Largest Creamery in the State
Two Automobile Repair Shops
Two Cotton Gins and Oil Mill
Wholesale Produce House
Concert Band, 23 Pieces
Fine Opera House
Cistern Factory

Two Railroads
Good Churches
$12,500 School Building
Pickle and Kraut Factories
Ten Different Secret Orders

Write to
"Flatonia Committee"
For Further Information

Civic-minded businessmen organized the Flatonia Committee in 1910. Like a modern economic development commission, it aimed to pull Flatonia out of an economic slump by offering inducements to bring new businesses to town. Perhaps its greatest achievement was in establishing the Flatonia Ice, Water, and Electric Company. This 1911 postcard advertises Flatonia's pride in its commercial and civic successes. (EAAAM/Jeanne Nikel.)

55

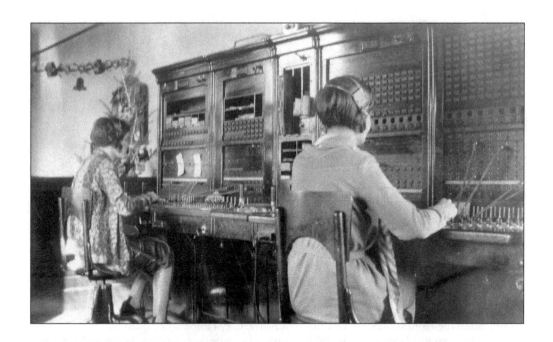

Certain limited "telephonic communications" had been established in Flatonia by individuals and small independent companies as early as 1885, but by 1900 Southwestern Bell Telephone had edged out all competitors. A directory was published in the *Flatonia Argus*, on August 16, 1900, with 51 business and residential listings for the Flatonia exchange. These two photographs from 1927 show the switchboard and switching equipment of the Southwestern Bell Telephone office soon after its move to the second floor of the new Flatonia State Bank building on the corner of North Main and Penn Streets. (Both, Martha and Arnold Tauch.)

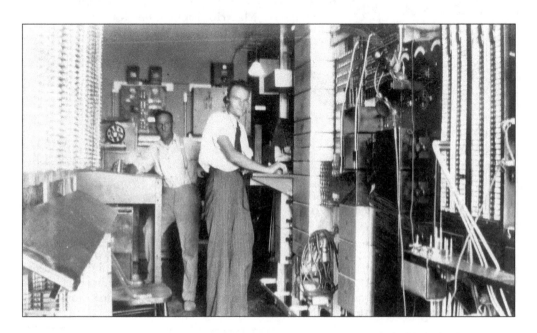

A job with the telephone company as an operator was a coveted position for many young women. Seen here in the 1940s outside the Flatonia State Bank building are, from left to right, (first row) Elizabeth Pechaceck, Henrietta Kubala, and Anita Chambers; (second row) Dorothy Pavlica, Jo Gabitsch, Emma Wiseman, and Iola Wehmeyer. Note the Southwestern Bell Telephone sign by the transom, upper right. (Sandra Pavlica Mica.)

Maxine Kunschik, Jo Gabitsch, Wilma Rietz, and Dorothy Mica, from left to right, are seen staffing the switchboard in this photograph from 1953. In 1955, with the introduction of new dial telephones, the Flatonia switchboard closed and operator assistance calls were routed to Rosenburg, Texas. (Jyl Faltisek Stavinoha.)

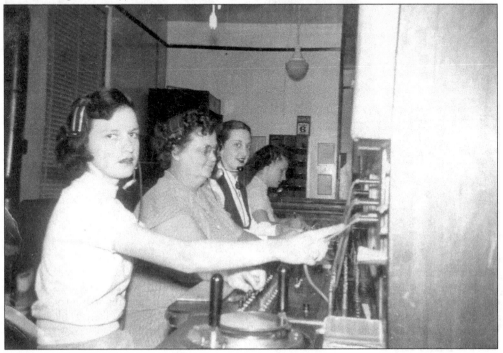

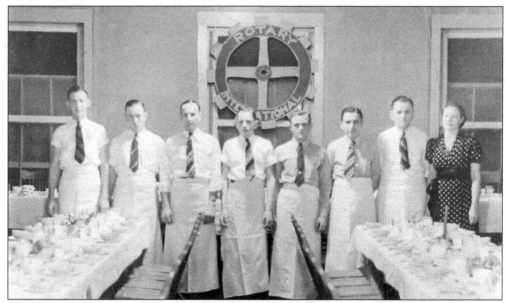

Moe Klein is credited with organizing the Flatonia Rotary Club in 1939. The Rotary motto is "Service Above Self" and several up-and-coming young businessmen, many of whom would themselves be members of the club one day, are seen here ready to serve at the charter presentation banquet on February 27, 1940. From left to right, they are W.W. "Sweet" Mueller, Joe Grieve, Paul Beale, Donald Garbade, Bill Tedd, Frank Novak, and Felix Brunner, along with his wife, Nettie Brunner. (EAAAM/Sandy Grieve Krause.)

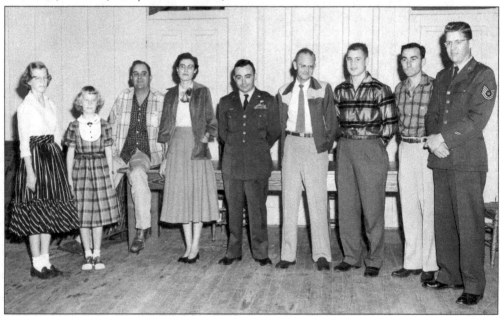

At the height of the Cold War, Flatonia organized its own Ground Observer Corps, a group of volunteers charged with identifying suspicious-looking airplanes and reporting them to the appropriate authorities. Pictured here in 1956 are Peggy Mueller, Ann Mueller, Henry Nikel, Jeanne Nikel, Capt. R.S. Kaplan (Houston Air Defense), R. Edward Stoner, J.B. "Botchey" Cook Jr., Walter Wotipka Jr., and Sgt. W.R. Stevenson (Bergstrom Air Force Base). (EAAAM/Jeanne Nikel.)

Four

FUN AND GAMES

Flatonia had the rough edges and lawlessness of a Western frontier town in its early years. It was not long, however, before upright citizens were calling for more stringent law enforcement and devoting their energies to the peaceable pursuits of a more law-abiding community.

Clubs and lodges proliferated with something to offer for every interest, from the Masonic Lodge to the Flatonia Shakespeare Club. Sporting events, especially baseball games, were crowd-pleasing favorites and guaranteed to stir up fierce competitions between neighboring communities. Roller-skating competitions, bicycle racing, horseback riding, shooting contests, and, of course, hunting and fishing all added to the range of possibilities that area citizens, participants and spectators alike, have enjoyed over the years.

As a stop on a major railroad, Flatonia played host to many a traveling tent show. Circuses, medicine shows, and dog and pony shows would spring up like mushrooms on open ground and then be gone just as quickly.

Some venues were established solely for public gatherings and entertainment, from simple outdoor dance pavilions to the Flatonia Casino Society. Chartered in 1879, the Flatonia Casino Society had nothing to do with gambling, but was rather intended to fulfill educational and social needs, with grounds regularly used for picnics, balls, and political rallies. From 1886 through 1923, three different buildings in town served as opera houses, bringing plays, musical acts, and variety shows to their stages and featuring both local and internationally acclaimed talent.

The Hermann Sons, a German fraternal insurance organization, established a very popular public park just southwest of the town. Though it was used for social and sporting events year-round, it is best remembered for the fall weekend when it hosted the Flatonia Fair (1913–1936) and it eventually became known simply as Fair Park.

Private parties and excursions frequently supplemented the public festivals, picnics, parades, and dances to entertain young and old alike. It all made for a lively social scene in a small town that liked to live large—and have some fun along the way.

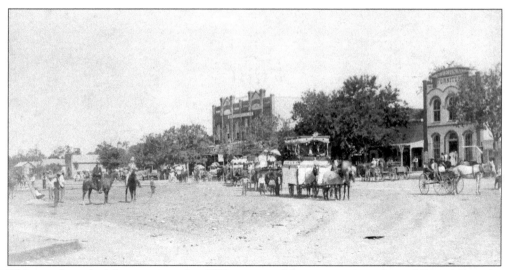

This parade marked the occasion of an 1893 reunion of the surviving members of Green's Brigade, a Confederate cavalry unit. According to the *La Grange Journal* of March 2, 1893, "near three thousand people were in the procession and on the streets, and everybody was well taken care of and made to feel at home, and happy." Speeches, a banquet, a concert, and a ball rounded out the day's festivities. (EAAAM/Ann and E.A. "Sam" Arnim.)

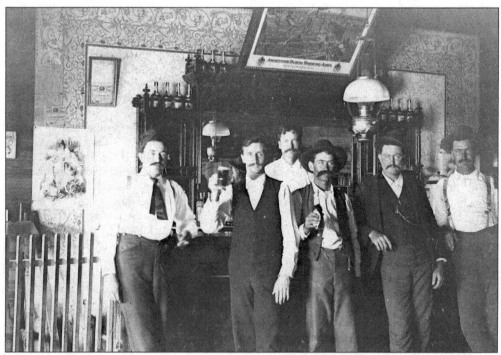

In its rough-and-tumble frontier town days, Flatonia was home to eight saloons at one time. In 1877, a correspondent complained to a local newspaper that Flatonia saloons sold "fighting whiskey"—a drink that was so strong it melted the plate in his false teeth. By the time this photograph of the Southern Pride Saloon was taken in the 1890s, gentlemen could relax in a much more refined establishment. (EAAAM/Betty and W.W. "Sweet" Mueller.)

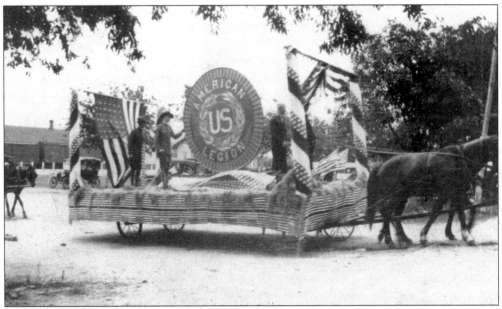

Flatonia veterans established American Legion Post 94 in 1919, immediately following World War I. One year later, they organized a "monster" May Day parade. According to the *Flatonia Argus* of May 6, 1920, it was attended by 2,000 citizens and surpassed "anything ever witnessed in this vicinity." In the photograph above of one of the patriotic-themed floats, veterans stand atop a bunting-draped wagon displaying a large emblem of the American Legion. The Army jeep below carries, from left to right, Katherine Brunnemann as "Columbia," Anita Foitik and Isabel Albrecht as her guards, and an unidentified soldier driving the vehicle. (Both, EAAAM/ Jean and Barney Wotipka.)

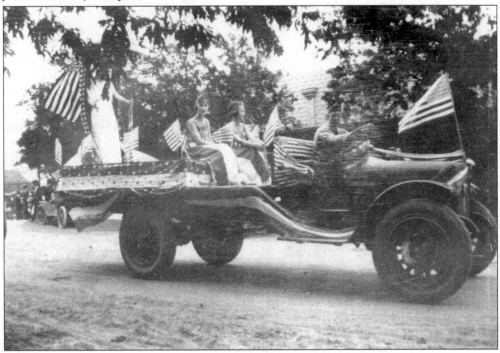

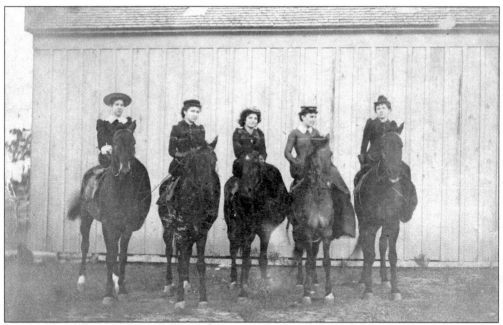

The young Flatonia "belles," seen here around 1896, are all decked out in perfect riding style, wearing black riding habits and hats and mounted to ride using sidesaddles. They are, from left to right, Mary Faires, Hattie Bludworth, Tummie Faires, Maggie McGill, and Mamie Burns. (EAAAM/Hildegard and Richard Wheeler Jr.)

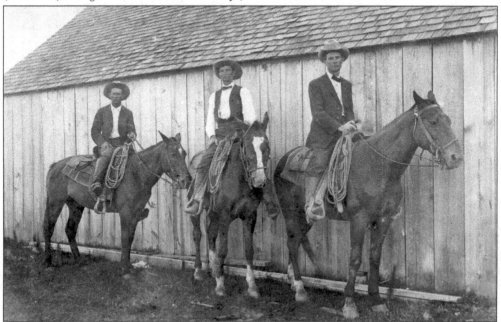

Gentlemen wore somewhat more utilitarian garb than the ladies when riding—though two are sporting bow ties in this photograph from about 1908. They would not be caught without their cowboy hats, saddlebags, and ropes, no matter what the occasion. The riders seen here are, from left to right, Jim Burns, E.E. Cockrill, and John Bludworth. The building behind them is probably the Snell & Cockrill livery stable. (Joseph Cockrell.)

Flatonia's Andrew Eidelbach, seen here with a chest full of medals, was a champion bicycle racer. Reporting on the 1888 San Antonio Fair, the *San Antonio Daily News* notes in its November 26 edition that Eidelbach won first prize in a no-hands, half-mile dash, placed first again in a three-mile race, and, in short, "carried off nearly all the honors and was the victor in the ten-minute exhibition of fancy riding." (EAAAM/ Ann and E.A. "Sam" Arnim.)

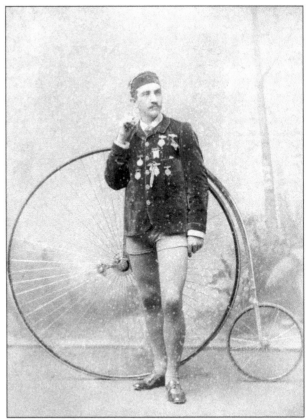

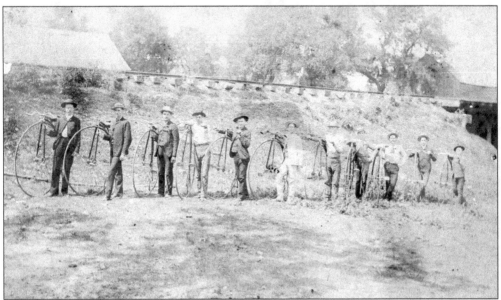

Lined up by the railroad embankment at the Seventh Street spur, a row of men with their big-wheel bikes testifies to the popularity of the sport in the 1890s. Interestingly, the photograph is marked on the back with the prices paid for each "machine," ranging from a mere $17.50 up to an astonishing high of $188, but the men are not named. (EAAAM/Ann and E.A. "Sam" Arnim.)

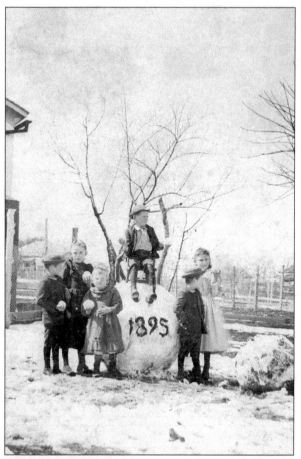

The *La Grange Journal* of February 21, 1895, reports that the thermometer "went down to 10 degrees above zero, and the snow fell to the depth of six inches, some say eight, and laid upon the ground for nearly three days." Anton Foitik photographed his own children and brother Rudolf's during this rare Flatonia snowfall. Pictured from left to right are Raymond, Alvina, Eulalie, Harry, Harold, and Anita. (EAAAM/Jeanne Nikel.)

In once popular "Tom Thumb" weddings, children played the parts of bride, groom, and all the attendants. This fundraiser for the Cemetery Association is described in detail in the *Flatonia Argus* of September 2, 1909. The flower girl in front is Annette Crane. The tall "minister" in white robe and surplice has been identified as Dewey Baugh, and standing arm in arm at his side in the center of the row are "groom" Richard Wheeler Jr. and "bride" Jeanette Mason. (EAAAM/Hildegard and Richard Wheeler Jr.)

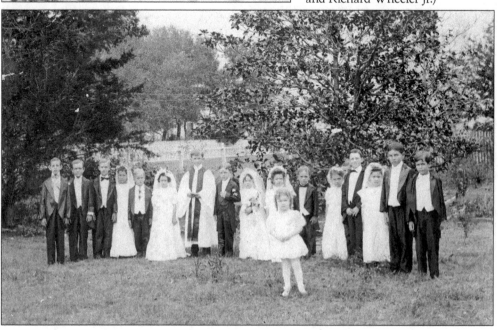

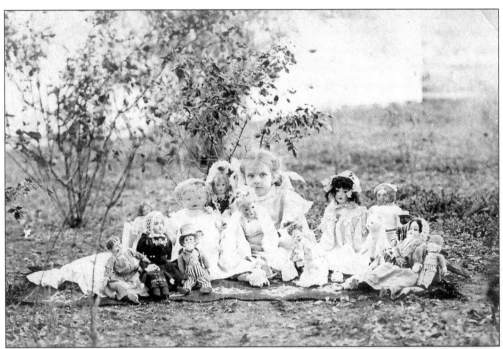

Margaret Laux, only daughter of the local postmaster, was the subject of a poem called "Neighbor Girl" by Lucie McCommon, which appears in the *Flatonia Argus* of March 16, 1911. In the poem, McCommon describes Margaret as "pretty as a peach," and alludes to the collection surrounding Margaret in the photograph above: "Of dollies, she has quite a lot, I think there are twenty-nine, dressed in the fashions of the day, of silks and satins fine." (EAAAM/Jeanne Nikel.)

Charlie Peyton Harrison II wears full aviator's regalia as he stands in front of his father's store on North Main Street in this photograph from about 1930. He might have imagined himself as a famous World War I flying ace, swooping around town on his Sopwith Camel biplane, also known as his trusty bicycle. (Family of John Moffett Harrison.)

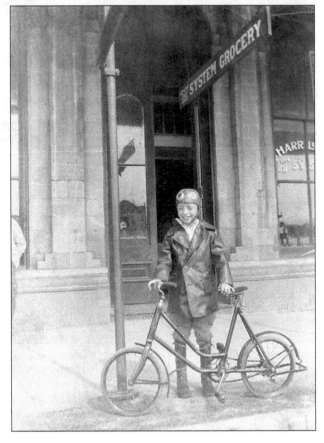

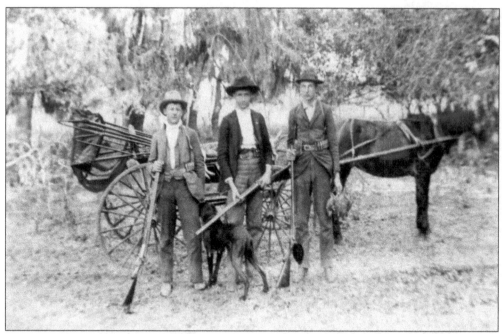

Fish and game were plentiful in the Flatonia area, making it a sportsman's paradise. Appearing in this photograph from the late 1890s, are, from left to right, P.A. Nikel, Louis Mueller, and Rudy Mueller—well equipped for the outing, with rifles, cartridge belts, and a hunting dog. Mueller appears to be holding a brace of birds in his left hand. (EAAAM/Rolla Mueller.)

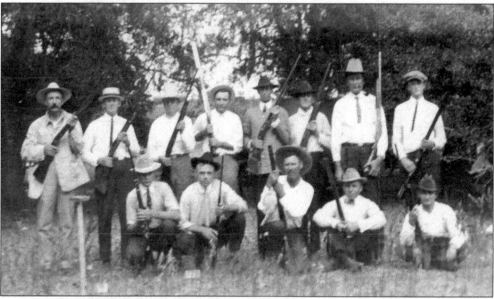

Shooting competitions flourished through organizations like the New Rival Gun Club, the Mutton Roast Gun Club, and the Flatonia Rifle and Pistol Club. Meeting for a trap shoot on the Wiedemann place south of town in 1924, these sportsmen are, from left to right, (first row) Bill Wiedemann, Hugo Stein, Harry Wiedemann, Joe Svatek, and Carl Amberg; (second row), Pete Finkenstein, Rob Walla, D.D. Garbade, Joe Sedelmeyer, Bill Garbade, Pete Nikel, R.F. Mueller, and Rolla Mueller. (EAAAM/Rolla Mueller.)

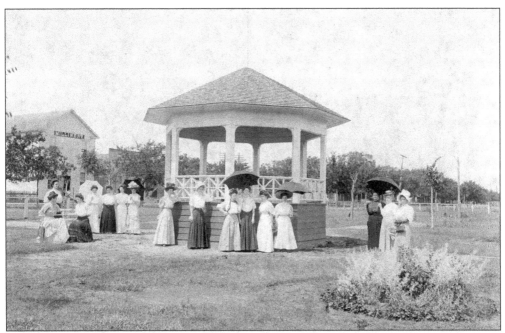

A group of local women with a taste for the classics organized the Flatonia Shakespeare Club in 1898. The club owned its own meetinghouse and published an annual calendar that outlined a program of study for each meeting through the year. This photograph from about 1911 shows the ladies of the club at the new bandstand in the City Park. (EAAAM/Hildegard and Richard Wheeler Jr.)

People occasionally like a bit of good, silly fun, even if they are the "grande dames" of the community. These ladies are posing during a "Tacky Party," where one dressed for a certain flamboyant effect, and definitely not for fashion. A few of the attendees for this 1938 event are, from left to right, Loraine Pulkrabek, Eulalie Wotipka, Sadie Kubena, Elizabeth Zappe, and Edna Daehne. (Family of Frances and Lonnie Garbade Sr.)

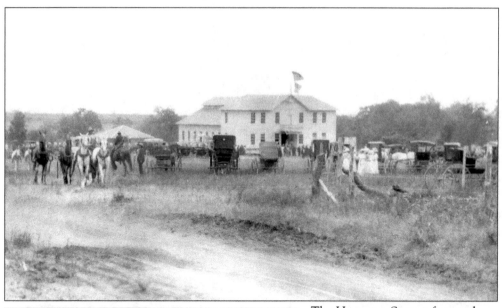

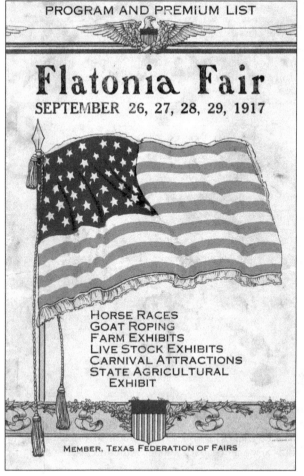

PROGRAM AND PREMIUM LIST

Flatonia Fair

SEPTEMBER 26, 27, 28, 29, 1917

HORSE RACES
GOAT ROPING
FARM EXHIBITS
LIVE STOCK EXHIBITS
CARNIVAL ATTRACTIONS
STATE AGRICULTURAL
EXHIBIT

MEMBER, TEXAS FEDERATION OF FAIRS

The Hermann Sons, a fraternal insurance order, built this large meeting hall in 1913. The new hall was the site of the Fourth of July celebration that year, and the event marked the beginning of what would become an annual Flatonia Fair. In addition to being used for Hermann Sons meetings, dances, and fair exhibits, it was used for graduation exercises and even basketball games before a school auditorium or a gymnasium was built. (Family of Margaret and A.J. "Duke" Freytag.)

This program cover from the 1917 Flatonia Fair lists just a few of the activities available during the four-day event. The fair drew huge crowds, with trains offering special excursion rates from neighboring towns. Competition was lively for best produce, livestock, canning, and ladies' fancy work. (EAAAM/Minnie Ungerer.)

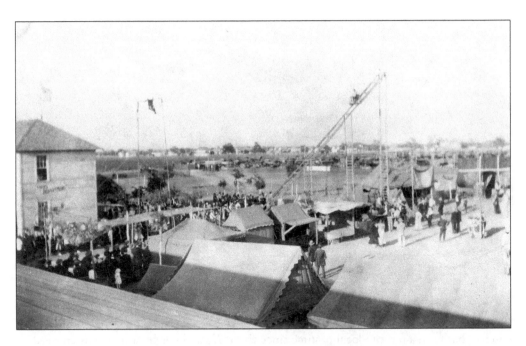

Parades, speakers, fireworks, dances, baseball games, a "better babies" competition, and a "Giggle Path" carnival were all a part of the excitement of the annual Flatonia Fair. The photograph above shows the Sensational Smithsons in their 1917 daredevil act, the "Twirl of Terror, Cycling the Chasm." The photograph below shows a carnival airplane ride, though by 1918, rides in real World War I–era biplanes would be available to the most daring fairgoers. Caught between a financial overreach in the construction of new buildings and declining attendance due to the Great Depression, the Flatonia Fair closed its doors for the last time in 1936. (Above, EAAAM/ Billie Grace Herring; below, EAAAM/Anita and Max Steinhauser Sr.)

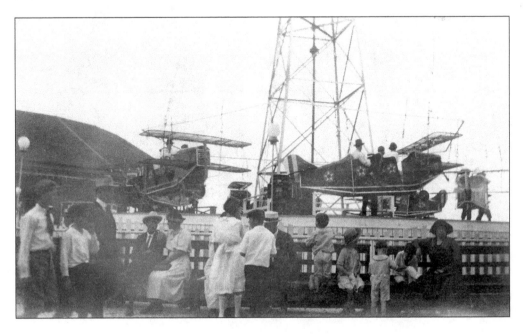

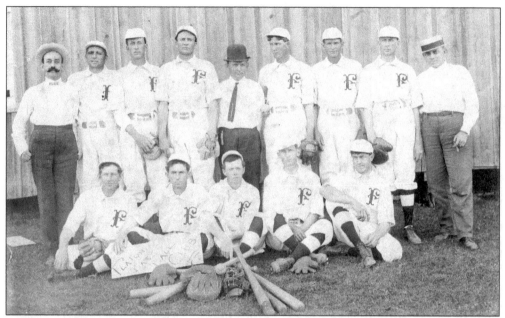

Baseball has been a favorite local pastime since the 1870s and neighboring towns engaged in "friendly" rivalries. The managers and players for this town team in the early 1900s are, from left to right, (first row) Jim Blanton, Fletch Sullivan, Lawrence Cockrill, Owen Faires, and George Fernau; (second row) Henry Miller, M.V. Meyer, Parvin Allen, Jim Dandson (pitcher), Richard Wheeler Sr., Lyt Allen, Abe Goode, Will Allen, and L.N. Lyon. (EAAAM/ Hildegard and Richard Wheeler Jr.)

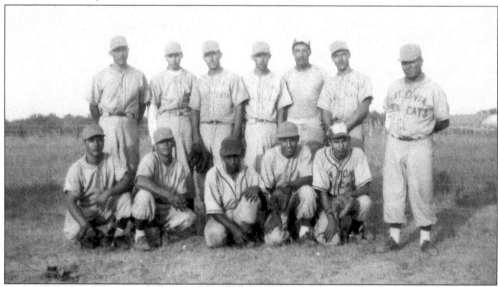

The Mexican American community fielded its own baseball team, known as the Flatonia Bobcats. A notice in the *Flatonia Argus* of May 27, 1948, invites the public to a Sunday afternoon game with the El Campo Tigers on the field near the auction ring. The team that year is pictured here: from left to right, (kneeling) Manuel Lozano, Gabriel Lozano, two unidentified, and Joe Melchor; (standing) Julio Lozano, Mike Estrada, Faustino Segura, Mateo Segura, Salvador "Pochel" Robledo, Pete Lozano, and manager George Delgado. (Janie Delgado Vanek.)

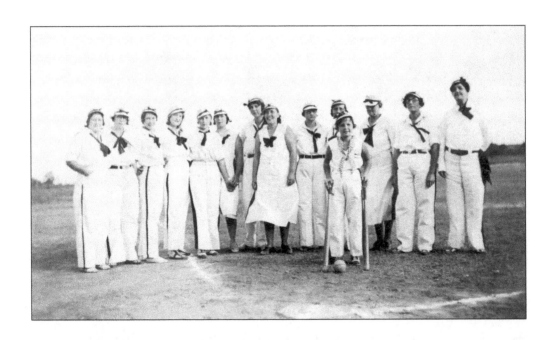

Not to be outdone where baseball was concerned, women organized two teams in 1931—the Fats and the Leans. The Fats team is pictured above in their snappy white uniforms. Each team also had its own cheering squad. The one for the Fats team is seen below, having robbed their kitchens of appropriate noisemakers—tin pots and lids—for the occasion. The *Flatonia Argus* of October 22, 1931, reports the game as a "thrilling affair, start to finish," but it ended in a tie in the eleventh inning "because it was getting late and the husbands were getting nervous about the evening meal." (Both, EAAAM/Margaret Laux Hamon.)

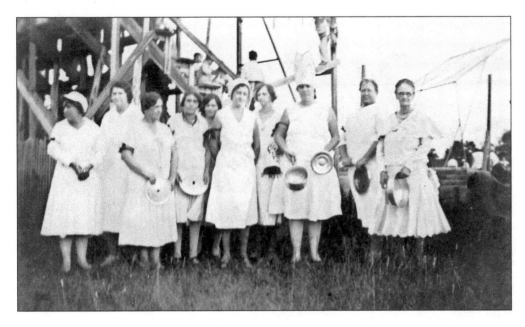

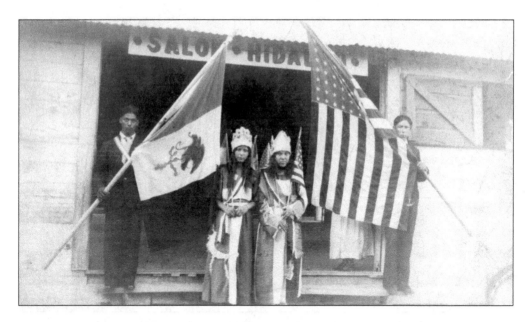

September 16 is the anniversary of Mexico's independence from Spain. In Mexican American communities across Texas, the date was commemorated with "Diez y Seis de Septiembre" celebrations. The photograph above from 1933 shows the fiesta queens and their escorts at the Salon Hidalgo in Flatonia. Representing Mexico and the United States, respectively, are, from left to right, Cruz Arguello, Juana Rosas, Ramona Rivera, and Juan Segura. The photograph below is from the 1951 celebration with, from left to right, Jesse Mejia and Cipriana Segura representing the United States, and Lucia Rosas and Joe Olmos representing Mexico. (Above, Rachel Delgado; below, Janie Delgado Vanek.)

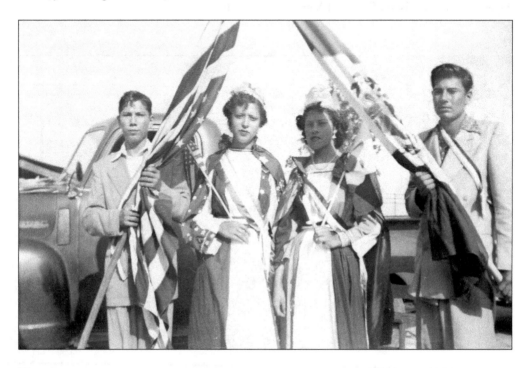

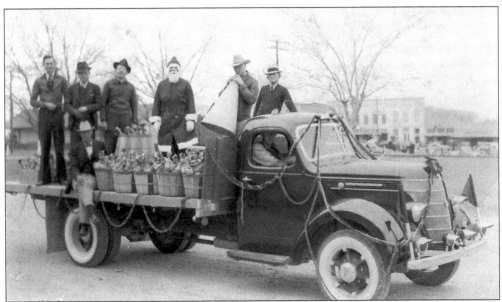

Santa Claus rode into town on a fire truck, bringing treats to generations of young Flatonia children. Each child received a brown paper sack filled with ribbon candies, peppermint sticks, an apple, and an orange. Pictured in 1938 are P.E. "Pink" Cooper, seated at the left, and in the cab of the truck, Lemon "Pud" Blackmon and A.L. Vrana; standing are, from left to right, Rev. James Reeves, a Mr. Weatherbe, George Hawkes, Paul Zappe Sr. as Santa Claus, George Hamon, and Gene Sullivan. (Family of Emily and G.T. Hawkes.)

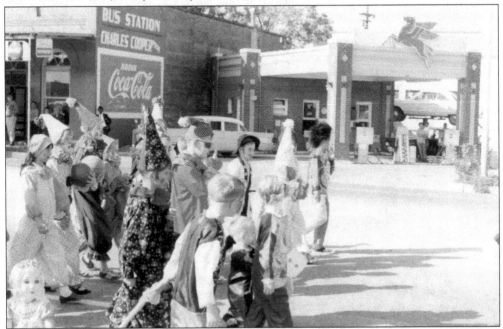

The fall festival at the Flatonia Public School was sometimes marked by a parade through downtown Flatonia, as seen in this photograph from October 1969. The young costumed marchers are passing along North Main Street in front of Charles Cooper's bus station and the Mobil filling station with its red Pegasus. (EAAAM/Rolla Mueller.)

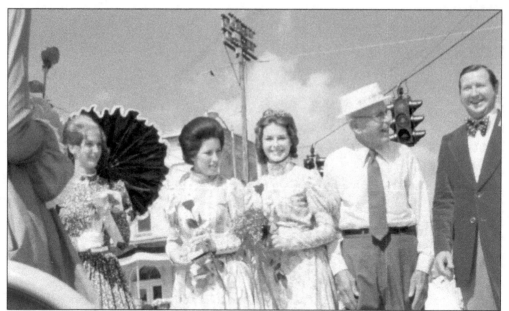

To celebrate its centennial in 1973, Flatonia threw one heck of a party, with a parade, the "world's largest beer tent," music, a carnival, arts and crafts, food booths, races, contests, and any number of other activities. Participants and dignitaries appearing on the main stage during the first queen's contest (above) are, from left to right, Cyndi Beale, Christine Simons, Donna Whaley, Hugo Stein Sr. (Flatonia's oldest citizen at that time), and Mayor Leslie Greive. The group of men pictured on North Main Street in their centennial boater hats (below) were all participants in a beard-growing contest. The festival and chili cook-off that was a part of the original event is called Czhilispiel and continues to be held every year on the fourth full weekend in October. (Above, Melba Richter; below, EAAAM/Rolla Mueller.)

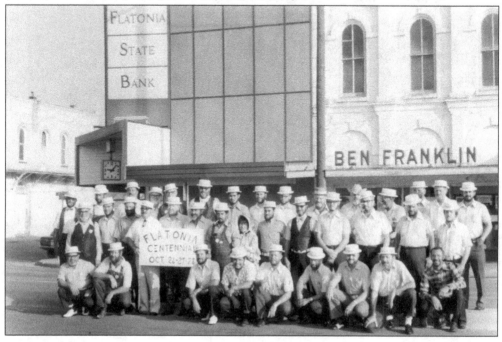

Five

TIES THAT BIND

Soon after Flatonia was founded, congregations began building permanent church structures, Baptists were the first to do so in 1878, followed by the Methodists in 1881. Two early churches served the black community: St. Paul African Methodist Episcopal, dating from about 1888, and the New Union Baptist Church, from 1895. Local Catholics generally attended church at nearby St. Mary's in Praha until they built their own Sacred Heart Church in 1912.

Along with churches, schools also serve to connect people within a community. Though tax-funded "free" schooling was long a subject of fierce debate, no one denied the importance of education. The City of Flatonia established the town's first public school in 1875. This school was in the southeast quadrant of the town, adjacent to a plot of land that would eventually become the primary campus of Flatonia Independent School District.

It was, however, not the only facility in town that served educational needs through the years. In the 1880s, the Casino School, established primarily for the German population, competed for pupils with the Flatonia Institute. Private schools were maintained from time to time as well.

Segregation meant that young African Americans long attended separate primary and secondary schools in Flatonia. For some years, secondary students were bussed 25 miles to attend high school in La Grange. Integration was only completed in Flatonia after the end of the 1965–1966 school year when Douglas Grade School closed and the building that had housed it was moved to the Flatonia Public School campus.

Schools have come and gone, buildings have been built, torn down, replaced, expanded, then torn down and replaced again. A graduate of the distinctive two-story brick schoolhouse of 1912 would never recognize the campus today, but school experiences, whether in the classroom or on the playground, on the athletic field or the auditorium stage, form the bedrock upon which lives and careers are built. Through each succeeding generation, school loyalties continue to run deep within the community and form lasting ties that bind.

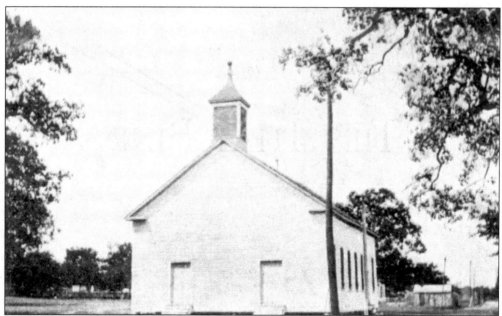

The Reverend Pinckney Harris presided over the dedication of the Flatonia Baptist Church on March 16, 1879. In addition to Flatonia, Harris's circuit also took him to Blackjack Springs, Luling, and Moulton. Presbyterians met here on first Sundays, and from 1900 through 1910, services were held in German on every third Sunday. A new brick sanctuary replaced this frame building in 1965. (EAAAM/Betty and W.W. "Sweet" Mueller.)

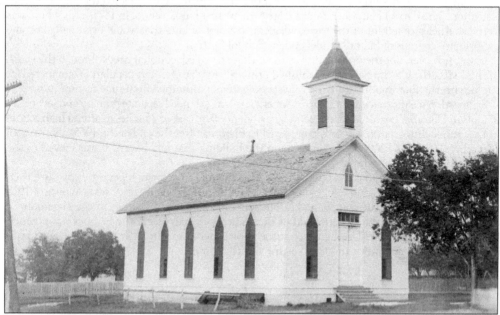

Arnim & Lane had the contract to build a Methodist church in Flatonia at a cost of $3,000. The Reverend T.F. Dimmitt preached the first sermon in the new church on August 8, 1880, but it was not dedicated until members retired the debt on March 27, 1881, with the Reverend E.S. Smith presiding. This simple but elegant structure, a Recorded Texas Historic Landmark, remains in service to this day. (EAAAM/Kate Lyon.)

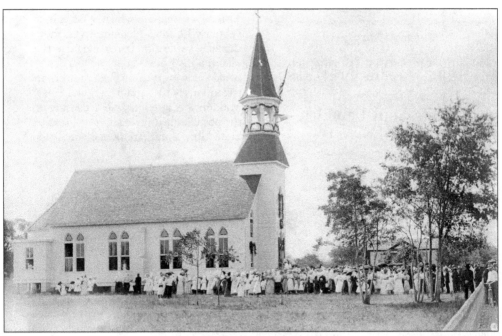

For many years, Flatonia Catholics had to travel to Praha or Cistern to attend services. This photograph shows the culmination of their efforts to get a parish church of their own, when the Sacred Heart Catholic Church was dedicated on September 17, 1912. This classically beautiful white frame church was moved from one side of Faires Street to the other in 1933 but was demolished in 1977 to make way for a more modern brick structure. (Gajdos family.)

Annual church picnics, or "grand bazars," as they were once called, are an old tradition, but this poster from 1930 advertises a menu similar to that served at church picnics today. It features a chicken and sausage dinner, music through the afternoon, and "various other amusements," along with supper and an old-time dance at night. This event was held at Flatonia's Fair Park until the church built a parish hall in 1940. (EAAAM.)

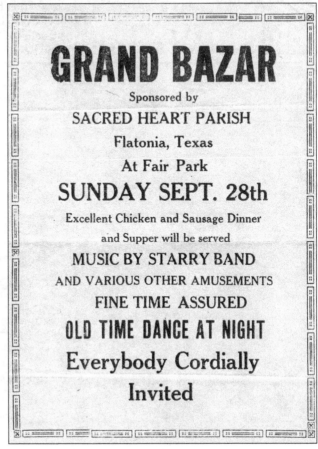

GRAND BAZAR

Sponsored by

SACRED HEART PARISH

Flatonia, Texas

At Fair Park

SUNDAY SEPT. 28th

Excellent Chicken and Sausage Dinner

and Supper will be served

MUSIC BY STARRY BAND

AND VARIOUS OTHER AMUSEMENTS

FINE TIME ASSURED

OLD TIME DANCE AT NIGHT

Everybody Cordially

Invited

This advertisement, which appears in the February 19, 1880, *Flatonia Argus*, shows the wide variety of classes offered at the Flatonia Institute. Males and females could study everything from rhetoric and trigonometry to "ornamental and fancy work, in wax and hair," all according to the posted schedule of charges. (Texas State Library and Archives Commission.)

The sons and daughters of many of Flatonia's oldest families are seen in this 1888 photograph of the Flatonia Public School. The photograph includes, from left to right (first row) Hix Woods, Rob Ragsdale, Sally Kerr, Maggie McGill, Emmie Bolton, and Molly Goode; (second row) Kate Wheeler, Daisy Howland, and Myrtle Burns; (third row) Frida Blucher, Charley Kerr, Grace Beckham, Clara Stockwell, Miss Waggner (teacher), Charley Amsler, Charley McGinty, and Roe Johnson. (EAAAM/Kate Lyon.)

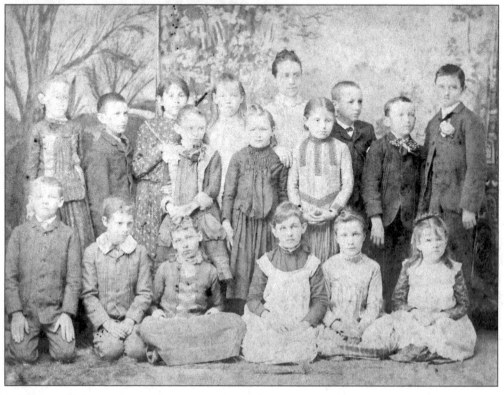

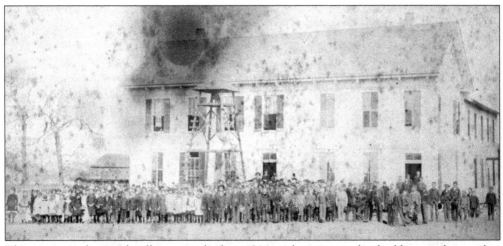

This two-story frame schoolhouse was built in 1884, replacing an earlier building on the site that dated from 1875. The *Flatonia Argus* reported in 1886 that there were 260 pupils enrolled at this school. They were divided into six regular grades, a music department, and a German school that had its own professor. (EAAAM/Betty and W.W. "Sweet" Mueller.)

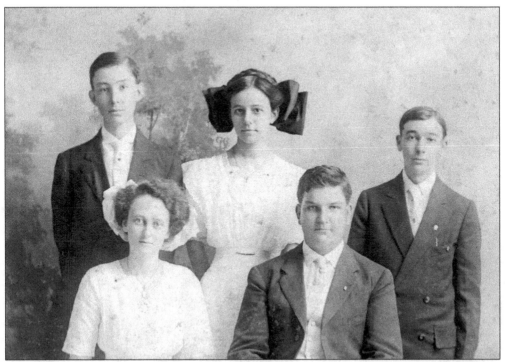

Though the graduating class of 1911 was small in number, its commencement exercises were large in ceremony. With no school auditorium, guests and floral tributes filled the city opera house to capacity, and performances of classical music alternated with solemn addresses. The five graduates are, from left to right, (first row) Bessie Stewart and Frank Brunnemann; (second row) Herbert Thulemeyer, Virginia Cowdin, and Frank L. Wotipka. (EAAAM/Jean and Barney Wotipka.)

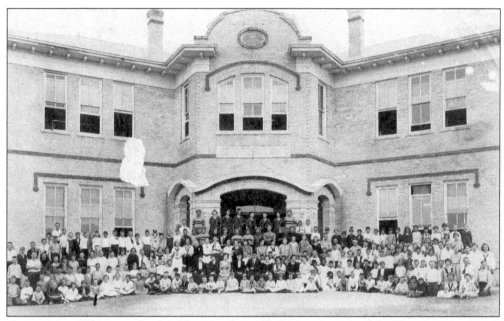

Generations of Flatonia schoolchildren fondly recall this two-story brick building, seen here with the entire student body in 1920. Looking closely, one can see four girls and three boys holding loving cup trophies for academic or sporting competitions. From the time it was opened in the fall of 1912 until a new high school building was added to the campus in 1930, this facility served all 11 years of primary and secondary education then offered. (EAAAM/Elizabeth and Frank Pechacek Jr.)

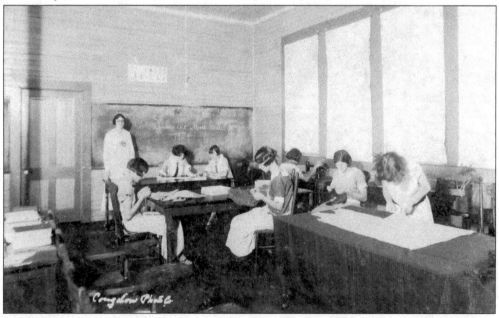

Instruction in the domestic arts was once a very important part of every young female's education. Here, a ninth-grade class learns sewing skills under the watchful eye of teacher May Bell Weyland in 1924. While several are engaged in hand stitching, one cuts out a pattern, and another uses the lone sewing machine in the room. (Joe M. Kelly Jr.)

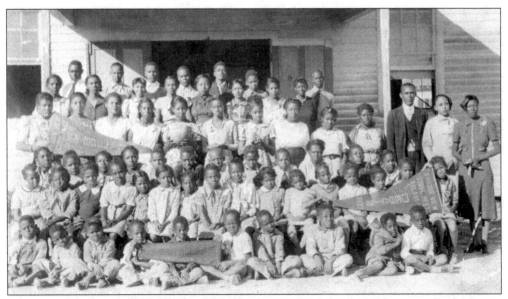

This 1937 photograph of Flatonia's Colored Normal School shows children proudly displaying banners won in spelling and debate competitions at the Prairie View State Meet. This school closed in the 1950s, and secondary students were bussed to a high school in La Grange until they were transferred to Flatonia High School in 1965–1966. Primary students continued to attend Douglas Grade School in Flatonia until the following year, when it closed and integration was completed in the 1966–1967 school year. (Earline Williams.)

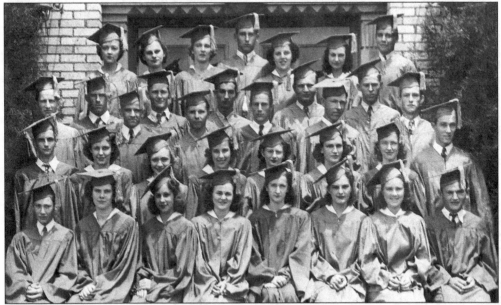

Though students did not know it at the time they posed for this graduation photograph, the Flatonia High class of 1942 was poised to become part of America's "greatest generation." This was the last class to participate in organized team sports until after World War II. Remarkably, 15 of the 17 male graduates seen here would soon be enlisted in the armed forces and therefore engaged in far more serious battles on foreign soil, while a number of the young women would support the war effort by taking up the jobs the men left behind. (Family of Martha Vyvjala Brunner.)

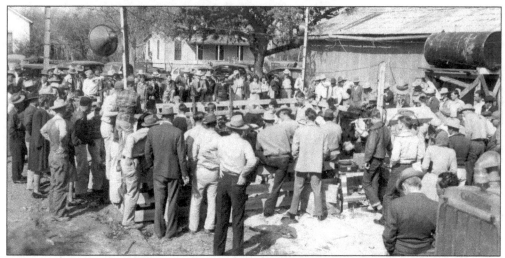

At an annual Fat Stock Show, members of Flatonia High School's Future Farmers of America (FFA) club showed calves, hogs, lambs, and chickens in a competition for Grand Champion and Reserve Champion designations. After they were shown, the animals were auctioned off, hopefully netting a profit for the young men who raised them. The photograph above shows the 1947 event, held in a vacant city lot. In later years, the show was held at the Flatonia Livestock Commission auction barn. These activities were always well supported by prominent businessmen within the community, many of whom are seen below in 1954. From left to right are (kneeling) Edwin Plowman, Christian Barta, Ira Syler Sr., and Lonnie Garbade Sr.; (standing) R.M. "Doc" Hagen, Wallace Cherry, Joe Grieve, Felix Brunner, E.A. "Sam" Arnim, Earl Needham, and Barney Wotipka. (Above, Lisa Janszen Lovett; below, Sandy Grieve Krause.)

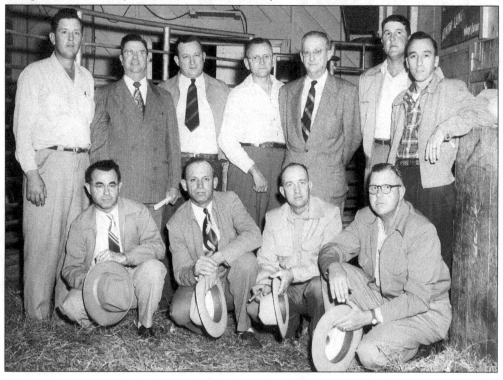

School plays and skits served an important role in a child's education, as well as affording pleasure for parents and others in the community. Mothers were usually tasked with sewing the costumes, and the memories were often captured on film, as in these two photographs from the 1920s. The flag-waving Uncle Sams and Lady Liberties of the 1922–1923 second-grade class seen above are, from left to right, (kneeling) Harvey Lackey, James Snell, Roland Sullivan, and Ernest Pechacek; (standing) Dolores Mueller, Margaret Rollig, Minna Marburger, and Eunice Garbade. Only two of the tramps have been identified in the sixth-grade class of 1924–1925 in the photograph below, both in the second row: Lamar Oltman at the far left, and William "Ted" Brunner at the far right. (Above, family of Margaret and A.J. "Duke" Freytag; below, EAAAM/William "Ted" Brunner.)

The Halloween Carnival and Coronation sponsored by the Parent-Teacher Association was one of the highlights of every school year. A queen was crowned from among a group of princesses and then attended by a royal household of ladies-in-waiting and duchesses, each with her own escort. A variety show followed, entertaining the royal court and the general public with skits and

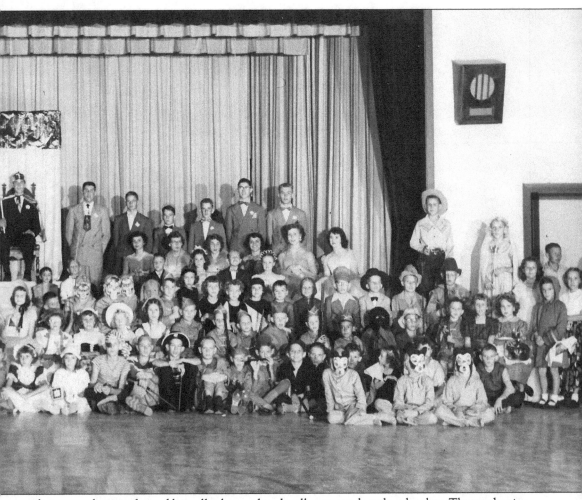

dance numbers performed by well-rehearsed and well-costumed grade-schoolers. The production was usually arranged around a central theme, and in 1953 the show was titled *A Story Book Ball.* Marcelyn Etlinger (queen) and Clyde Parker (king) pose here with their court and the pageant's entire cast of characters. (Susan Johnson.)

The first Flatonia High football team was organized in 1912, and its first game was played against a Yoakum team that arrived in town by train. Seasons were short and opponents varied in those days, with no districts or divisions based on size. In 1925, when Franklin Nesrsta, Lester Webb, and Frank "Dutch" Daehne were star players for the Flatonia Bulldogs (left to right, above), Flatonia even played Austin High, with a hard-fought 19-0 loss. Among several notable athletes to come out of Flatonia, Daehne was a four-year letterman in four sports at St. Mary's College in San Antonio. In a 1937 game (below), the teams face off on a makeshift field. Following a hiatus during World War II, the Bulldogs returned to the gridiron in 1946 and the school purchased land for a new lighted field for the 1947 season. (Above, family of Frances and Lonnie Garbade Sr.; below, family of Emily and G.T. Hawkes.)

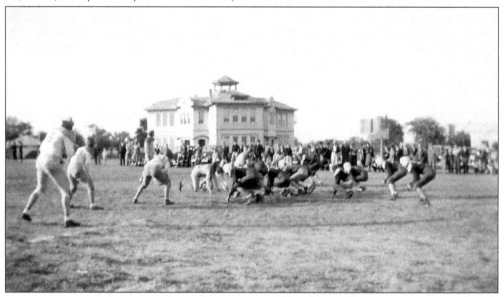

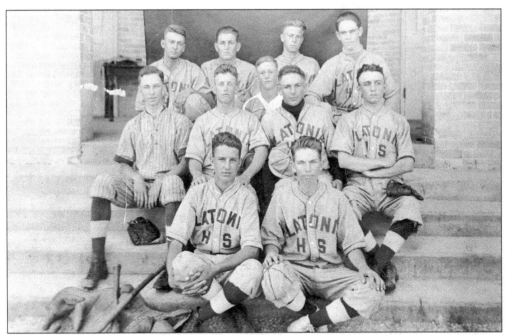

The Flatonia High baseball team of 1921 appears to be outfitted in snappy new uniforms. The players seen here on the school steps are, from left to right (first row) James Gosch and Lawrence Bailey; (second row) Henry Hurr, Maro Williamson, Edwin Olle, and Arthur Anderle; (third row) Carl Emory, Vladimir Pospisil, Allen Webb, unidentified, and Joe Bludworth. (EAAAM/ Jean and Barney Wotipka.)

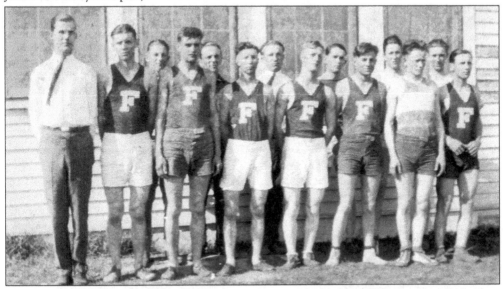

Flatonia made it to the state basketball tournament in 1924 and almost did it again in 1925, when its previously undefeated team was stopped at bi-district with a 13-11 loss to Austin High. The stuff of local legend, this team consists of, from left to right, (first row) Coach Vastine Gosch, Bennie Pospisil, Aurelius Pospisil, Bennie Herzik, Allen Webb, and three unidentified; (second row) Otto Hanna, unidentified, Bill Daehne, unidentified, Harold Foitik, and Frank Daehne. (Family of Frances and Lonnie Garbade Sr.)

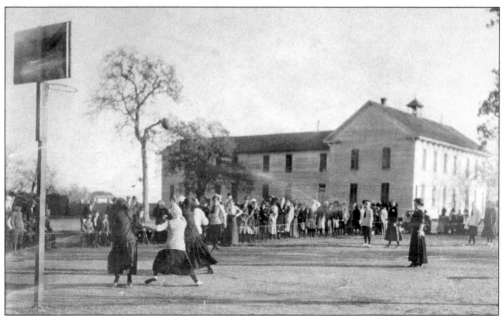

Girls, too, loved their school sports, as can be seen in this spirited game of hoops in 1911 (above). Their long skirts do not appear to be a hindrance as they contest for possession of the ball. All Flatonia basketball games were once played on outdoor courts, such as this one located in the lot next to the public school building. In 1924, they moved indoors at Fair Park Hall, where the bloomer-clad girls in the photograph from 1925 (below) would have played their home games. Pictured are, from left to right, Dora Williamson, Carrie Williamson, Lillie Finkenstein, coach May Bell Weyland, Annie Stachney, Maggie McDonald, and Edna Albrecht. (Above, EAAAM/ Cowdin family; below, EAAAM/Elizabeth and Frank Pechacek Jr.)

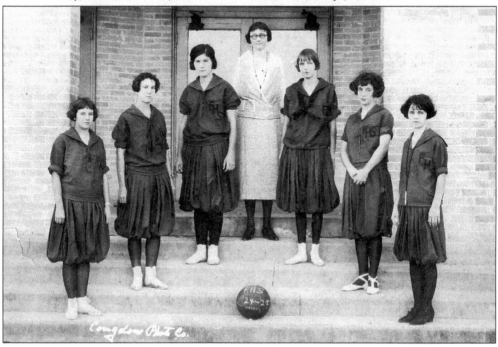

During the Depression years, the Flatonia girls' volleyball team had to find games close to home against traditional rivals like Schulenburg, as well as smaller country schools like Scott's School and Freyburg, and even scratch boys' teams—just for practice. The girls on this 1934 team are, from left to right, Pauline Hobizal, Esther Vybiral, Martha Machac, Dolores Gebert (captain), Anita Tauch, Elsie Walla, and Avis Davis. (EAAAM/Anita and Max Steinhauser Sr.)

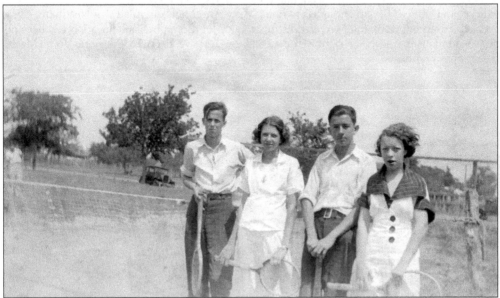

In 1934, a column called the Bulldog reported school scholastic and sporting activities in the *Flatonia Argus*. From this source, it is known that both the boys' and girls' doubles tennis teams won their preliminary games for the county meet competition that year, but they failed to advance to district games. Seen here by the net are, from left to right, John D. Eidelbach, Bonnie Brueggemann, Joe Sedelmeyer, and Maxine Hodanek. (EAAAM/Anita and Max Steinhauser Sr.)

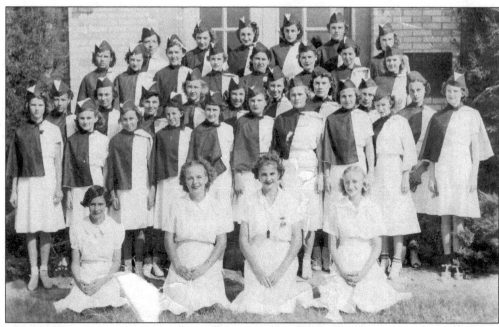

What would high school athletics be without cheerleaders and a pep squad to root the teams to victory? These two photographs show just two variations in the uniforms worn through the years. The cheerleaders in 1938 (above) are, from left to right, Lorraine Gray, Marjorie Vrana, Mary Gene Logan, and Hazel Brown. While they wear simple white skirts and blouses, the pep squad costume added capes and caps reminiscent of nurses' attire. The cheerleaders and mascots of 1952 (below) are sporting the fashionably short skirts of that era, all in the school colors of maroon and white. They are, from left to right, Mary Ann Migl, Virginia Lynn Needham, Doris Pospisil, Susan Johnson, and Marcelyn Etlinger. Lucy Johnson, physical education teacher and pep squad sponsor, is at the far right in the second row. (Above, EAAAM/Marjorie Vrana Mach; below, Susan Johnson.)

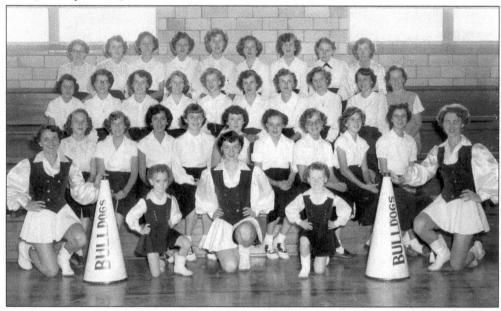

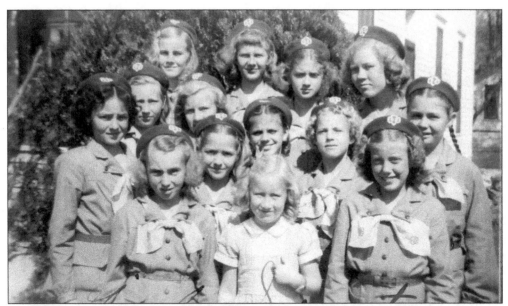

Girl Scouts typically learn valuable skills outside the classroom and treasure lifelong memories of their experiences. Club members posing here in 1950 are, from left to right (first row) Pauline Florus, Lanette Pavlica, and Myrna Maeker; (second row) Doris Pospisil, Betty Hobizal, Mary Ann Migl, Mary Ann Janak, and Betty Earl Plowman; (third row) Norma Fajkus and Joy Pavlica; (fourth row) Ramona Nauman, Marcelyn Etlinger, Sylvia Fajkus, and Audrey Otto. (EAAAM/ Pauline Florus Farek.)

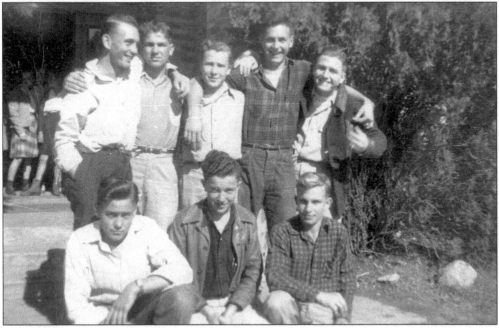

This photograph of a group of young men from the 1946–1947 school year shows the relaxed camaraderie of high school friendships. From left to right are (kneeling) Marvin Nollkamper, Jerry Faltisek, and Victor Zouzalik; (standing), Leroy Florus, William Cherry, Daniel Zouzalik, Richard Earl Brunner, and Thomas Scates. (EAAAM/Jeanne Nikel.)

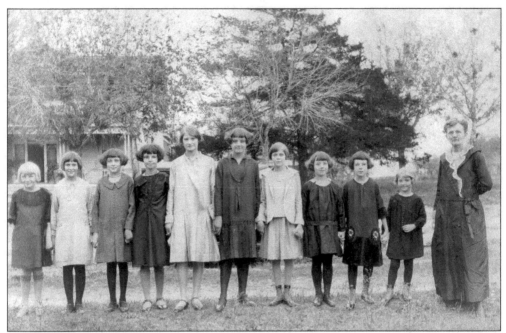

For those who could afford them, private piano lessons were offered as an adjunct to the public school curriculum. Pictured here in 1926, a few of the young ladies privileged to receive such training are, from left to right, Kathryn Price, Margaret Rollig, Eunice Garbade, Elizabeth Lambert, Evelyn Bittner, Gertrude Wotipka, Audrey Bailey, Elsie Walla, Hildegard Ungerer, and Alcinia Webb, along with instructor Ollie Bailey. (EAAAM/ Hildegard and Richard Wheeler Jr.)

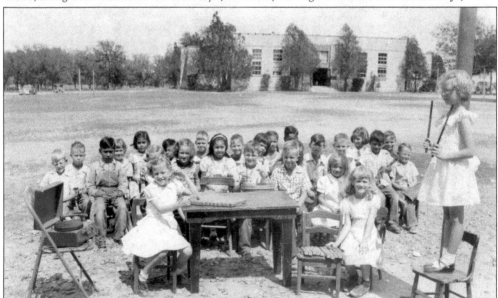

For many years, a first introduction to music in public school classrooms came in the form of a rhythm band. Children kept time to a phonograph record with rhythm sticks and xylophones. In 1951, the leaders of this group of budding musicians from Miss Ward's first-grade class are, from left to right, Peggy Mueller and Lillian Byler on xylophones, and Becky Garbade on the chair with rhythm sticks. (Family of Frances and Lonnie Garbade Sr.)

Before becoming superintendent in 1959, R.B. Froehner was high school principal and taught civics, history, and driver's education. Pictured here in 1955 with Froehner directing at the far right, the choral club was his pet project and was a very popular extracurricular activity for his students. (EAAAM/R.B. Froehner.)

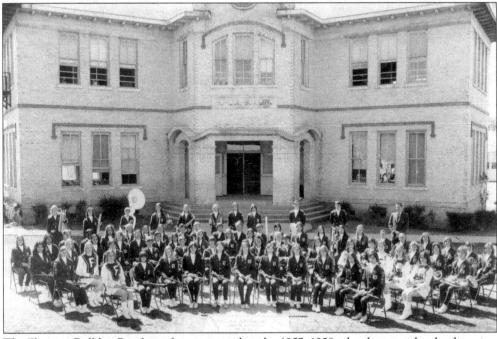

The Flatonia Bulldog Band was first organized in the 1957–1958 school year under the direction of Gus Streithoff. In its early years, students as young as the fourth grade marched at halftime for football games. The band had gained some polish by the time this photograph was taken in the 1973–1974 school year. Flatonia native and band director George Koudelka, standing in back at the far right, played drums for this same band during his school days. (George Koudelka.)

These two photographs from the 1953–1954 school year show just some of the support staff that kept the school running smoothly. Standing in front of the old frame building that once served as a lunchroom, the women in charge of cooking and serving meals (left) are, from left to right, Edna Vrana, ElizabethPlowman, and Annie Doehring. A new brick elementary classroom and cafeteria building was opened on the campus just a year after this picture was taken. Longtime janitor Anton Penn is seen mowing the grounds in front of the high school building (below). (Both, EAAAM.)

Pictured from left to right, teachers Lois Null (third grade), Josephine Doms (sixth grade), and Beatrice Kasper (fifth grade) pose in front of the two-story building in 1952. The long and steep fire escape slide, seen over their heads, was an exhilarating—or frightening, as the case might be—feature of an annual emergency evacuation drill for students in second-floor classrooms. (EAAAM/Dora Koch McCall.)

The Parent-Teacher Association (PTA) engaged in many activities to support education in Flatonia. In the 1953–1954 school year, when this photograph was taken, there were 400 students on the campus and 285 PTA members. The executive committee members seen here are, from left to right (first row) Ida Maeker, Betty Mueller, Lois Null, and Mary Stein; (second row) Dora McCall, Elizabeth Syler, Elizabeth Plowman, and Dorothy Wampler. (EAAAM.)

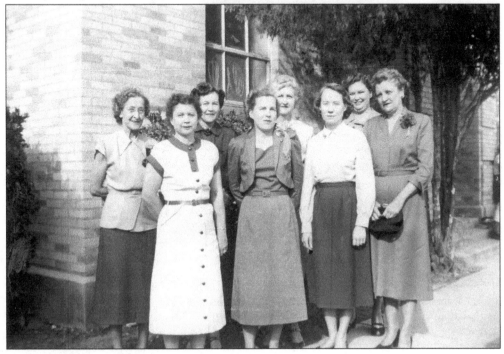

This photograph from 1948 shows a typical spring afternoon and a relaxed after-school gathering of students and teachers at the main entrance to the high school building. The young women seated on the steps are identified as, from left to right, Henrian Swofford (Home Economics teacher), Annie Jo Schmidt, and Anna Bell Doehring. High school principal R.B. Froehner is seen enjoying a good laugh, standing in back at the far left. (Lisa Janszen Lovett.)

For many years, a senior trip was an exciting cap to the high school experience and was for some, no doubt, their first chance to venture beyond the state lines of Texas. Though many classes stayed closer to home with trips to places like Galveston or Corpus Christi, this bus carrying the class of 1955 was on its way to Florida. David Johnson (left) and Ervan Zouzalik are standing at the rear of the bus, which proudly declares their place of origin. (Jeanette and Ervan Zouzalik.)

Six

THE AGRARIAN LIFE

Flatonia sits at a point where blackland prairie on the east side gives way to post oak savannah on the west. Initially, at least, the former was more given to cultivation of crops, the latter to livestock and timber. But both areas seemed to be quite fertile and proved very attractive to farmers looking for land at a few dollars per acre. They considered cotton to be an important cash crop, but grew a variety of vegetables, fruit, and nut trees for both market and home consumption. Livestock generally included cattle, horses, sheep, goats, hogs, and poultry.

In its heyday of agriculture, the area produced prodigious quantities of cotton, beef, hides, wool, dairy products, poultry, eggs, corn, cabbages, and cucumbers. Besides fresh products shipped to distant markets by rail, small local industries grew up to process some of these commodities prior to distribution. The railroad may have been the engine that first drove Flatonia's economy, but farms and ranches provided the fuel.

With the passage of time, the land would undergo many changes. Drought, the dreaded boll weevil, overgrazing, under-rotation of crops, soil erosion, foreclosures on farms during the Great Depression, mechanization, and the steady attrition of farm laborers following World War II—all would have their various effects on local agriculture. By the 1950s, the landscape had quite a different aspect than it did in the late 19th and early 20th centuries. Cotton had all but disappeared, and many a cultivated field was left to become pasturage for cattle.

There were always exceptions, however, and as actual cultivation of the land declined overall, other forms of agriculture came to the fore. A very successful auction barn was established to provide a local market for livestock. From many small egg farms in existence at one time, one emerged as a major regional force in caged egg production. Support industries, such as trucking to haul grain and feed stores to sell it, continued to play an integral role in the local economy and, despite all the changes, Flatonia has maintained its deep roots in the land.

Following the Civil War, much of the area around Flatonia was farmed by Czech and German families. The land near Fivemile Creek, a few miles west of Flatonia, brought bountiful crops to the Tauch family. Immigrant Henry Tauch bought acreage adjacent to the railroad from T.W. Pierce, president of the GH&SA Railway, in 1883. Henry's son Paul carried on the farming tradition on the same property. In the above photograph from about 1910, Herman and Ella are seen helping their mother, Anna Kurz Tauch, prepare huge cabbages to produce sauerkraut, a winter staple, while baby Arnold looks on. Pictured below many years later, Anna shows off a fine harvest of turnips on the back porch. (Both, EAAAM/Ella Tauch Sievers.)

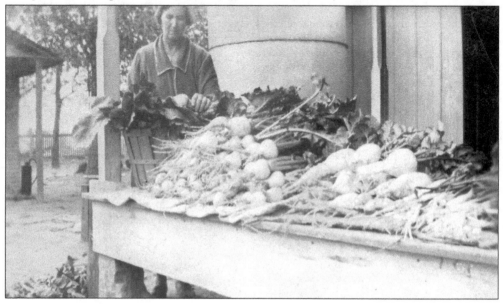

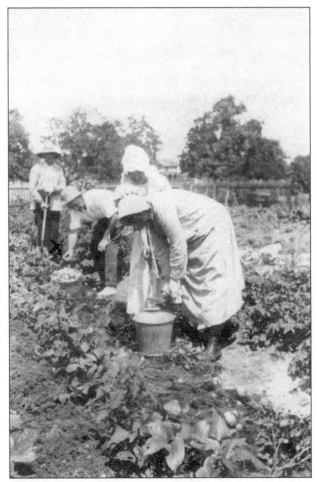

When vegetables were ready to be harvested, it was often a family affair with all hands on deck to do the work. In the right photograph from 1915, several Greive cousins—one of them on a summer visit from California, another a "city" girl from Flatonia—are seen digging potatoes on the Greive farm near Praha. In the photograph from the 1920s below, the Tauch family home can be seen at the end of many long rows to hoe. Though they appear to be dressed more for visiting on the front porch than for working in the fields, several members of the family have apparently been enlisted to pick beans and perhaps were rewarded with a mess of them to eat afterward. (Above, Mike Horning; below, EAAAM/Ella Tauch Sievers.)

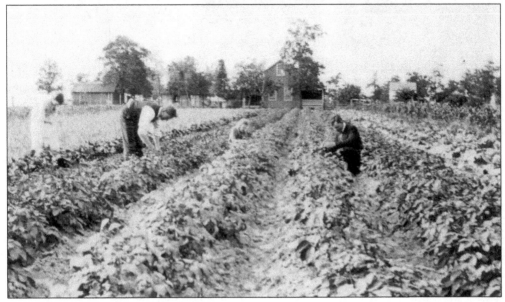

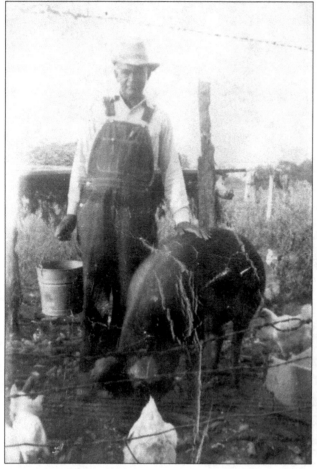

A considerable sprawl of barns, sheds, and pens stood behind the neat, but modest, family home of Otto T. and Annie Brunner Steinhauser. Max, one of nine Steinhauser siblings, is seen here in the late 1920s astride one of the farm's hardworking horses. A silo, only the second to be erected in Fayette County, is visible at the far left over the roofline of the barn. (EAAAM/Anita and Max Steinhauser Sr.)

Clem Armstrong, a prosperous farmer in the Armstrong Colony area, shows off some of his livestock, including a very sleek looking hog. Armstrong's ancestors were among those freed slaves who established Armstrong Colony about a decade after the Civil War, and for whom it was named. Many descendants of these early African American settlers still have homes and ranches in this area today. (Barnie Hollingsworth.)

Long before Flatonia became a major center of egg production in the state, places like Simmons Produce and, later, Southern Produce, purchased poultry and eggs in quantities from local farmers and processed them for resale. On the Tauch farm (pictured above), Anna is seen removing empty shells from an incubator. Ella, holding a doll, and Arnold are admiring the newly hatched baby chicks, while Herman rides his bicycle in the background. In the photograph from the 1940s (below), Emilia Gajdos (left) and an unidentified friend are looking over the flock on the Gajdos farm south of Flatonia. By the 1950s, long chicken houses with caged layers were dominating the commercial market, but free-range birds such as these, and their fresh-laid eggs, continued to be the source of many a housewife's special fund for Christmas gifts or little personal needs. (Above, EAAAM/Ella Tauch Sievers; below, Gajdos family.)

A farmer's day was often defined by milking chores, first thing in the morning and again the last thing before dark. There was always a ready supply of milk, cream, butter, and cottage cheese to show for the effort. The whole family is getting into the act around 1916 (above) as, from left to right, Herman Tauch stands ready with his milk pail, siblings Ella and Arnold watch over their young baby sister Anita in the wagon, and their mother, Anna, comes prepared to work with her milking stool and pail. Mathilde Wiedemann (below) approaches her Jersey cow, milk pail over her arm. By the time this photograph was taken in the 1920s, Wiedemann had retired back to her farm following a long career as a nurse and caregiver in the eastern states. (Above, EAAAM/ Anita and Max Steinhauser Sr.; below, Wiedemann family.)

Fernanda Olvera Delgado (left) and Maria Hernandez Rosas are seen here holding lambs or baby goats in about 1935. In Mexican American families, it was customary for the mothers of the bride and the groom, called *comadres* in Spanish, to give young animals such as these as wedding presents to the couple just starting a new life together. (Rachel Delgado.)

Sheep have almost disappeared from the landscape in the area around Flatonia, but, at one time, wool was an important local agricultural commodity. The *Flatonia Argus* reported shipments of 311 sacks of wool in 1876. It was still a cash crop as late 1917, when (from left to right) Fred, Fred's son Freddie, and Harry Wiedemann are pictured here shearing sheep on the Wiedemann family farm south of Flatonia. (Wiedemann family.)

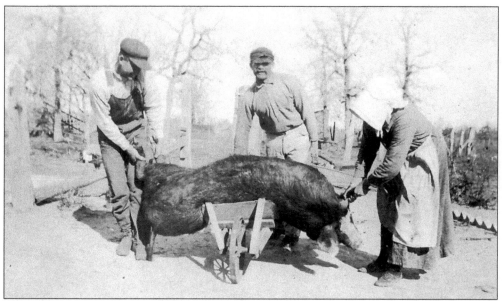

Pork was an important part of a farm family's diet—not only for the hams, hocks, and bacon, but also because smoked sausage was a savory treat that could carry a family through long periods when fresh meat was not available. Butchering could only be done in cooler months to reduce spoilage, and families often joined together in meat clubs to butcher hogs or calves, each in turn, to share fresh meat. Seen here around 1915 are, from left to right, Herman, Paul, and Anna Tauch. (EAAAM/Ella Tauch Sievers.)

Giving a good demonstration of a crosscut saw in action, two Rietz brothers team up to lay in a ready supply of firewood for winter. A typical farmhouse required a lot of fuel for wood-fired cooking stoves and wood burning heaters or fireplaces. (Jyl Faltisek Stavinoha.)

Erecting a good hayrick was an art. The dry cut grass had to be stacked in a proper width/height ratio and sloped inward to prevent toppling. A farmer would only cut into the rick in the winter when fresh forage for livestock was no longer available. Seen here in 1915 on the Henry Greive farm near Praha, several men pitch the hay up high while boys stand on top and tamp it down. (Mike Horning.)

It has been suggested that this implement, flanked by two unidentified men, is a hand-operated hay baler. Farmers began baling hay into "square" bales bound with wire or twine. These could easily be hauled and stored in barns, rather than left outdoors in the customary ricks, such as those seen here in the background on this farm near Muldoon. (Virginia and Harold Boehnke.)

It was usual for children of all ages to be engaged in all sorts of work around the farm. The school year often started late for farm children after all the crops were in for the winter. Here on their farm near Praha, the Lala family poses for a photograph as they bring in some corn with a horse-drawn wagon. (Gajdos family.)

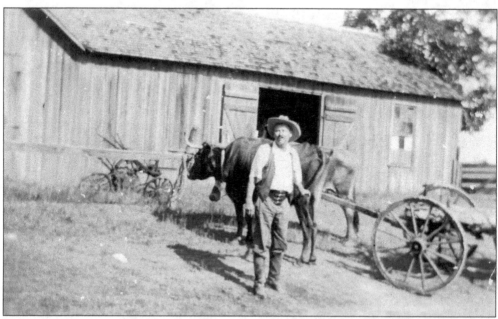

Harry Wiedemann is seen here with a double-yoked oxcart on his farm south of Flatonia. A plow that would typically be drawn by horse or mule also sits by the barn in this photograph from the 1930s. In addition to farming, Wiedemann was a mail carrier on a rural route, and in his leisure time he especially loved all sorts of hunting, fishing, and competitive shooting. (Wiedemann family.)

Paul Rietz is hauling a bale of cotton in this photograph from about 1935. At one time, Flatonia was home to two cotton gins and a cottonseed oil mill. Farmers used to race to harvest the first bale to earn a cash prize. Boll weevils, white cotton root rot, and a general depletion of the soil eventually spelled the end of cotton's dominance of crops in the area. (Jyl Faltisek Stavinoha.)

Giant crookneck squash, thought to be cushaws, have filled a wagon and lie gathered in piles in this photograph from about 1914. This appears to have been a bumper crop, but while still prized in the Deep South for use in pumpkin pies, cushaws are not now generally grown on a commercial scale. (EAAAM/Ella Tauch Sievers.)

A horse-drawn hay rake is pictured here on the Rietz farm near Cistern in about 1925. Eliminating the need for hand raking, this implement gathered the cut and dried grass into rows, where it could be loaded onto wagons and stacked onto hayricks. (Jyl Faltisek Stavinoha.)

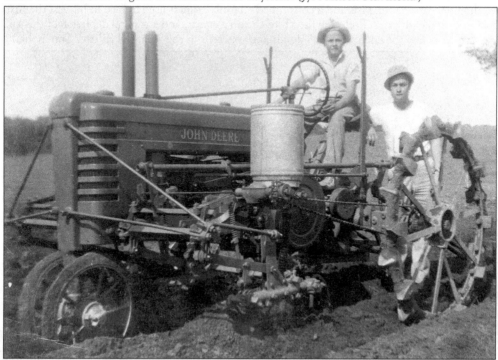

The automation of farm equipment, and especially the introduction of gasoline-powered engines, greatly reduced the need for manual labor on farms. This was especially important when young men began seeking their livelihoods off the farm after World War II. Brothers I.J. Pavlicek (left) and Edwin "Papoose" Pavlicek continue to help on the family farm near Praha with a John Deere tractor in about 1948. (Jan Zapalac Lahodny.)

Seen here on a Sunday in 1915, Henry B. Greive; his wife, Josephina; their 11 children; and a nephew from California are all dressed and ready to attend Mass at St. Mary's Church in Praha. Though they are posed in the family's workaday farm wagon, someone noted on the photograph that it took three horse-drawn buggies to transport them all to church. (Mike Horning.)

Though farmers might work from sunup to sundown most days, they usually reserved Sundays to attend religious services and visit with family and friends. Demonstrating that life was not all work and no play, the Gajdos family is seen here enjoying a watermelon party in the 1940s. Though the friends are unidentified, Joseph and Emilia Gajdos are standing at the far left, with their son Raymond at the far right. (Gajdos family.)

The strains of piano, violin, or accordion enlivened many an evening after farm chores were completed. Phonographs like the one pictured became immensely popular, playing songs recorded on wax cylinders. Pictured here in 1909 are, from left to right (first row) infant Arnold Tauch, Anna Kurz Tauch, Johanna Kurz, Johann Kurz, and Richard Kurz; (second row) Herman Tauch, Ella Tauch, and Paul Tauch. (EAAAM/Ella Tauch Sievers.)

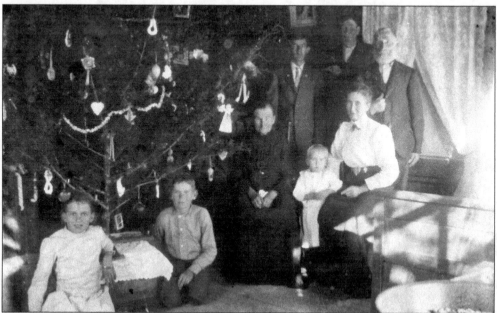

The Tauch and Kurz families visited often throughout the year and, of course, celebrated Christmas together. Gathered here in 1909, they are, from left to right (seated) Ella Tauch, Herman Tauch, Johanna Kurz, and Anna Kurz Tauch, with Arnold at her knee; (standing) Carl Kurz, Richard Kurz, and Johann Kurz. The tree is a large cedar found on the property and decorated with strings of popcorn and homemade ornaments. (EAAAM/Ella Tauch Sievers.)

Seven

GOOD NEIGHBORS

Small trade centers once served vast stretches of farm- and ranchland in southwestern Fayette County. Black Jack Springs, Mount Pleasant, Cistern, Elm Grove, Pin Oak, Oso, Mulberry, and "old" Flatonia predated the arrival of the railroad that established "new" Flatonia as a regional commercial hub.

With an influx of Czech immigrants, Mulberry was renamed New Prague, and later simply Praha, after the city in what these newcomers probably called the "old country." Colony and Armstrong Colony were established at roughly the same time as Flatonia, in the mid-1870s.

The area around Muldoon was first settled in the 1830s, but the town itself was established in 1887 with the arrival of the railway. It was named for Father Miguel Muldoon, a colorful character in colonial Texas history who had once owned the league of land upon which it stands.

Some of the older communities, such as Black Jack Springs, Pin Oak, Oso, Mount Pleasant, and old Flatonia, all but disappeared with the advent of rail transportation and shipping, leaving only cemeteries behind. Others, like Cistern, Elm Grove, Colony, Armstrong Colony, Praha, and Muldoon thrived in their own right, but not as the rather more substantial towns their founders might once have envisioned. Over the years, diminishing trade and dwindling populations reduced them to small collections of schools, churches, and perhaps a mercantile store or two, until most of these eventually closed as well.

The communities were good neighbors all, but today only Cistern retains some commercial activity, with a country store and a sausage factory. For the others, all the merchants are long gone and all the country schools have closed their doors. Active churches, at least, do remain in Praha, Muldoon, Elm Grove, Armstrong Colony, and Cistern, at the heart of communities that have declined in population but never in spirit, or in a sense of their own place in history.

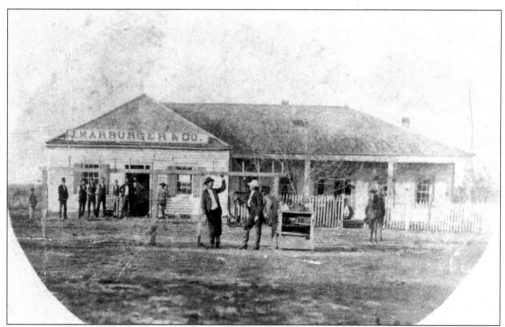

The community of Cistern was first called Whiteside Prairie, then Cockrill's Hill, after early settler Starks Cockrill, and later named Milton, after Cockrill's eldest son. When a post office was established in 1858, there was already a Milton in Texas, so it became Cistern, after the stone-lined cistern in the Cockrill store, the source of the only good drinking water in town. James Marburger's store is pictured here in 1878. Marburger served as Cistern's postmaster from 1877 to 1901. (EAAAM/Jean and Barney Wotipka.)

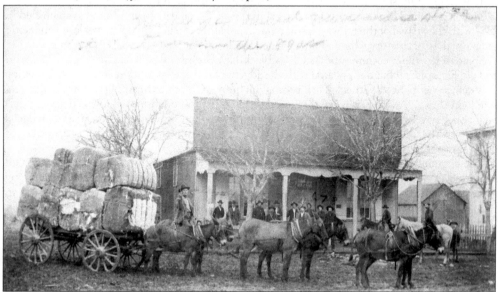

James Marburger built this new store building in 1888. Seen here in 1896, a heavily loaded mule-drawn wagon stands in front, ready for the 12-mile haul to the Flatonia depot. The bales of cotton were shipped to Galveston, and the teamster made the return trip with a stock of dry goods, groceries, and hardware for the mercantile store. Marburger is standing on the porch, second from left. (George Koudelka.)

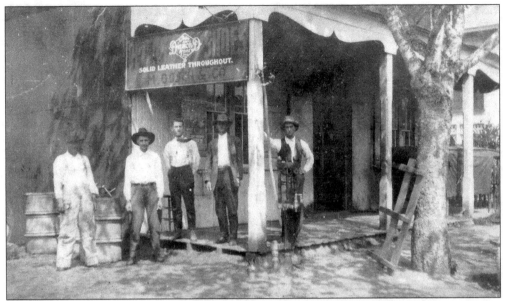

Monroe Gosch eventually took over the Marburger mercantile store. Seen here in the 1920s, this general store still served as Cistern's post office, and Gosch was the postmaster from 1920 to 1923. Though the two men at the left of this photograph are unidentified, those on the porch are, from left to right, Monroe Gosch, N. Brown, and John Holubec. (EAAAM/Mike Steinhauser.)

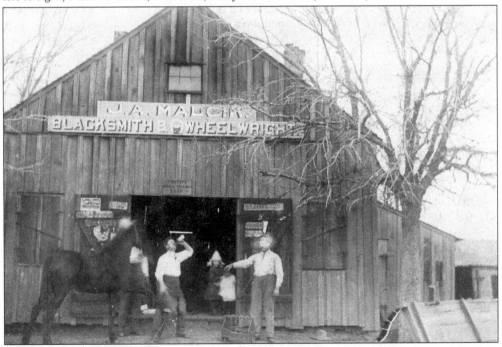

The 1914–1915 *Texas State Gazetteer* shows Cistern to have a post office, a telephone connection, and a population of 100. In addition to several ranchers, it had two general stores, a physician, a druggist, a cotton gin, a real estate agent, a milliner, and a blacksmith. John Anton Malcik, blacksmith and wheelwright, is taking a pause to refresh at the center of this photograph from 1914. (EAAAM/Ebelle Malcik Morrill.)

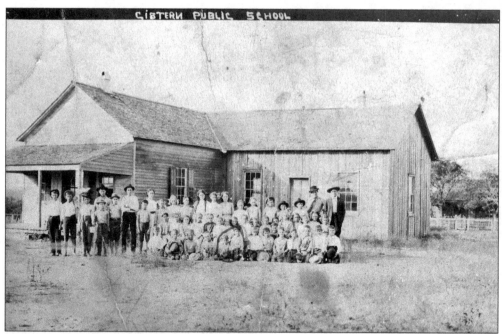

This photograph from around 1910 shows children posing in front of one of Cistern's first public school buildings. This schoolhouse is thought to be the one that was constructed just west of the public square in the late 1880s. Various lodges used it as a meeting hall and several congregations held church services there. (EAAAM/Jean and Barney Wotipka.)

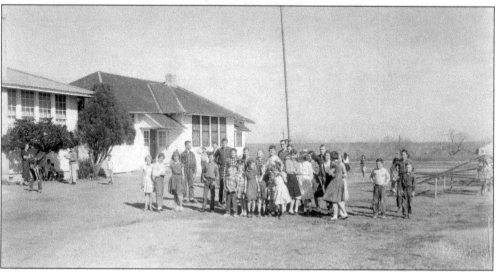

The building seen in part at the left was constructed in 1941 to house the Cistern Public School when it moved to a site on the road leading toward Muldoon. Students are at recess out in front of the classrooms in this photograph from about 1958. Cistern continued to maintain its own public school until the 1970s, when it closed and its students transferred to Flatonia. (Virginia and Harold Boehnke.)

Cistern's St. Cyril and Methodius Church was built in 1890 to serve the area's growing population of Czech Catholics. The two-story Shade Saloon was moved to the church grounds in 1918 to house a parochial school—nuns lived upstairs and taught in classrooms downstairs. This school closed in 1950, but the church is still active today and the exterior still looks much the same as it does in this 1940 photograph. (EAAAM/Ebelle Malcik Morrill.)

Even with a dwindling population, Cistern could still field its own softball team in 1947 and a rousing game against the Flatonia Farmers or the Muldoon Yellowjackets provided exciting entertainment for many a summer afternoon. Lined up here after a hot game are, from left to right (kneeling) Albert Bauers Jr., J.C. Matocha, and Charles Lee Bauers; (standing) Charlie Matocha, umpire Albert Bauers Sr., Edward Vinklarek, Alvin "Chick" Vinklarek, Vencil Mares, Leroy Florus, Alvin Gosch, Ernest Vinklarek, and Beno Matocha. (Betty Otahal Danner.)

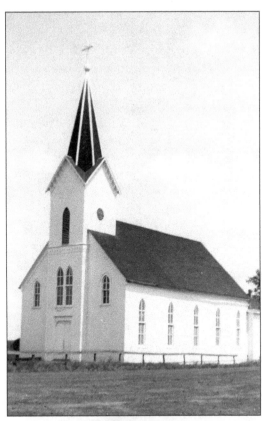

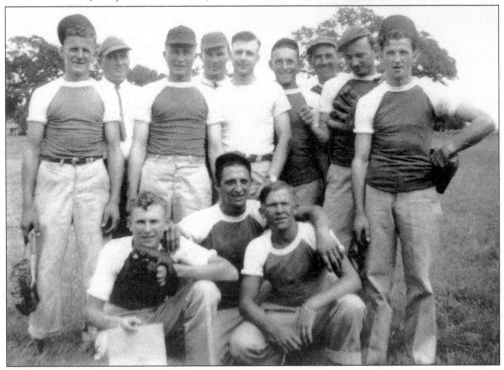

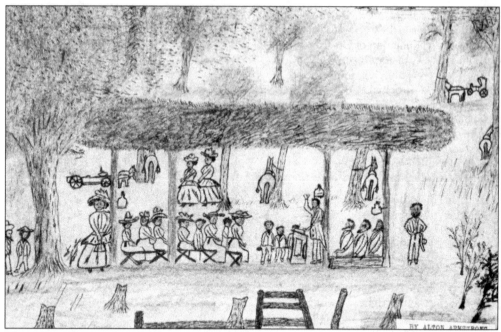

This folk art drawing by Alton Armstrong depicts the brush arbor where the first church services were held in Armstrong Colony after freed slaves settled the area in the 1870s. Taking the name Mt. Olive Baptist Missionary Church, the church was organized in 1876 by minister of the Gospel and schoolteacher O.E. Perpener. (Felton Armstrong.)

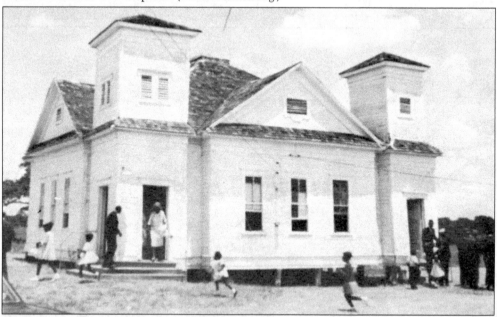

The Mt. Olive Baptist Church met in a log cabin until the Reverend F.D. Davis launched a drive to build a new home for the church. Designed by one of the members, Thomas Simms, and paid for by its members, this white frame building was completed in 1918. Though replaced by a brick structure in 1994, it is seen here on a Sunday during the congregation's centennial year of 1976. (Mt. Olive Museum & Cultural Center.)

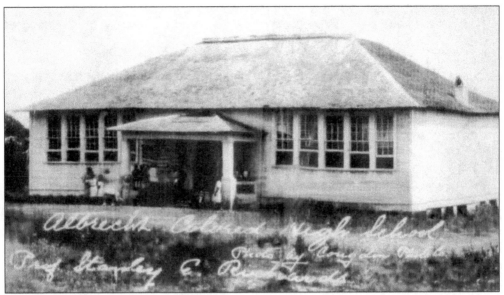

The African American population of Armstrong Colony believed strongly in the value of education. Largely funded by local donations, this school was dedicated with great fanfare on Friday, October 27, 1922. A 1949 commencement program provided by Ethel Derry Warren Clayborne confirms that the school operated at least through the end of the 1940s. (Mt. Olive Museum & Cultural Center.)

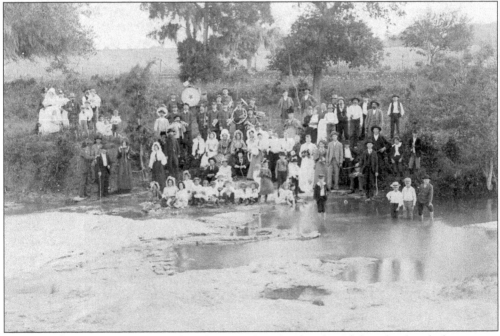

The community of Oso was settled in the 1850s, but the church and the school took their names from this nearby natural spring-fed pool called Pine Springs. Long after Oso faded into obscurity, the springs continued to attract excursions from Flatonia. This appears to be a wedding party, photographed around 1905. The Flatonia Concert Band, in uniform and identified by the drum, stands at the back of the crowd. (Fayette Heritage Museum & Archives.)

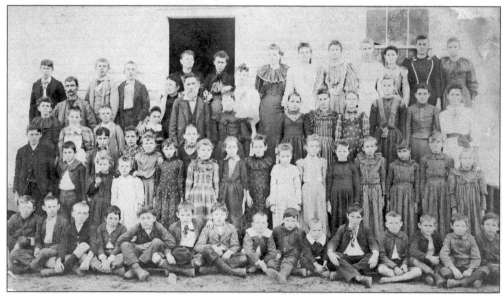

The Elm Grove Missionary Baptist Church, said to be the oldest Baptist church in Fayette County, was established in 1855. It helped organize Flatonia Baptist Church and several others in the county. The present building dates from 1880 and is seen here in the 1890s with a host of young people dressed for Sunday school. The church is still active today, and all that remains of a once thriving community. (Ginny Needham Sears.)

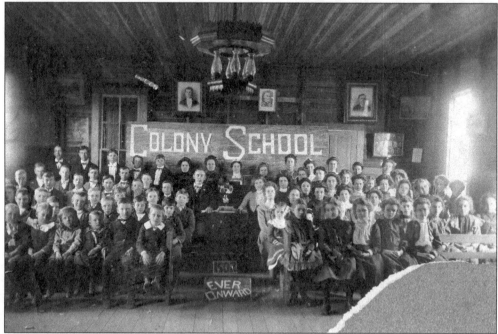

Colony was named for a "colony of Mississippians" who settled eight miles northwest of Flatonia in the 1870s. The *Texas Gazetteer* of 1890 lists a population of 100, a blacksmith, a flour and feed mill, a lawyer, a land agent, a carpenter, and a physician. Though only a cemetery and church building used for reunions remain, this school photograph from 1902 attests to the number of families living in this area in the early 1900s. (Bennie Beale.)

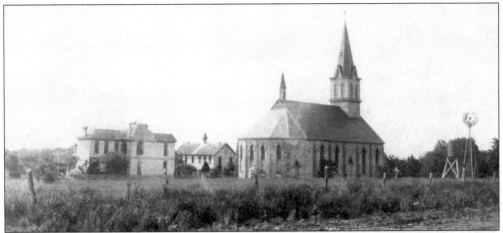

St. Mary's Catholic Church has been at the heart of the community of Praha since Czech Catholic immigrants began settling here in the 1860s. This church, the third on the same site, dates from 1895 and was constructed from stone quarried in Muldoon. Also seen in this 1915 photograph are the original buildings housing the rectory (left) and the parochial school (center). (Mike Horning.)

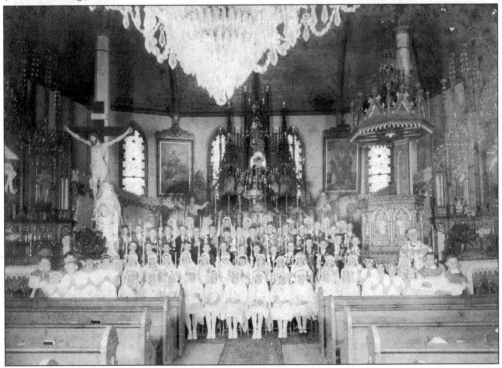

Boys and girls are seated in St. Mary's Church of Praha for their first Holy Communion. While it remains an active parish church, St. Mary's is also a considerable tourist attraction as one of Fayette County's beautiful "Painted Churches"—so called because of their ornate painted interiors reminiscent of their central European roots. The ceiling of the church, embellished with trompe l'oeil architectural details and a garden of ferns, vines, and flowers—which can barely be seen here in this photograph from the 1930s—was the work of Swiss immigrant and artist Gottfried Flury. (Gajdos family.)

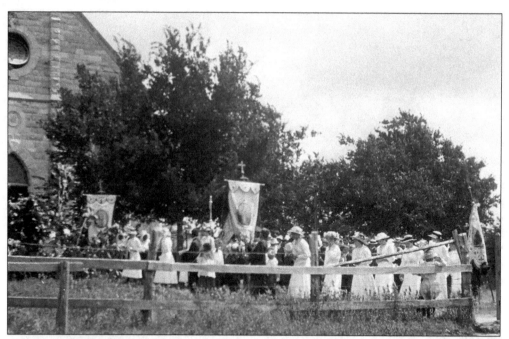

August 15 is the Catholic Holy Day of Assumption. Every year, Praha celebrates the day with a Mass and a feast. Thousands, many of Czech descent, come home to Maticka Praha (Mother Praha) for the Praha Picnic—a day of great food, great music, and maybe just a little *pivo* (beer). This photograph shows the August 15, 1915, procession to Mass. (Mike Horning.)

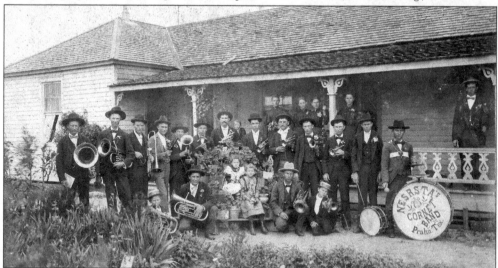

Much of the social life of small towns and rural areas revolved around music and dancing. Eventually, almost every community had its own dance hall, but dances were regularly held in homes or on outdoor wooden platforms long before that. The Nesrsta Cornet Band of Praha was in great demand for all manner of festive events. Seen here in about 1910, members are, from left to right, (first row) four unidentified, Emil Lev, and Raymond Nesrsta; (second row) Anton Lev, Stanley Marik, Felix Nesrsta, Karel Nesrsta, Jacob Hobizal, Anton Janek, Andres Shuman, Frank Vyvjala, Frank Forda, Joe Pospisil, Frank Nesrsta, Frank Zieglbauer, and Karel Lev; (third row) unidentified boy, four Nesrsta daughters, and Anton Nesrsta at the far right. (Gajdos family.)

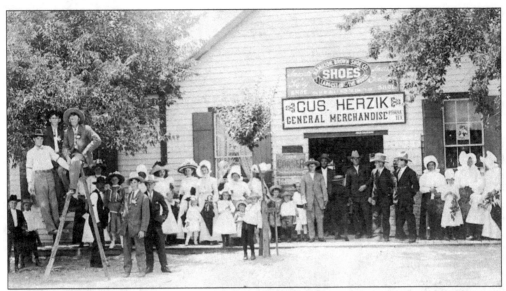

This Praha celebration is thought to be one that honored soldiers returning from World War I. According to the July 31, 1919, *Flatonia Argus*, about 40 soldiers were present for the feast, where dignitaries addressed the crowd in "Bohemian" and English. Anastasia Mikulik Pellech (wearing a white bonnet and holding a black umbrella) and her daughter Martha are standing in front of a shutter on the left. (Martha and Arnold Tauch.)

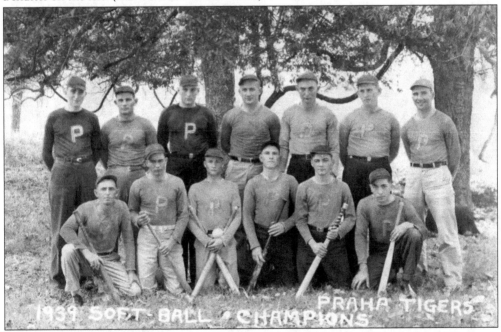

Playing in a league that included teams from Flatonia, Engle, Moulton, Muldoon, and Freyburg, the Praha Tigers won three games in a five-game series against the Flatonia Reds to become the 1939 softball champions. Pictured are, from left to right (kneeling) Frank Muras, Otto Pavlicek, Edwin "Papoose" Pavlicek, Alfred "Fritz" Zapalac, Johnny Doubrava, and George Pavlicek; (standing) manager Tim Bily, Jerome Darilek, manager August Bily, Emil Janak, Bohus Novak, Henry Janak, and Fred Herzik. (Jan Zapalac Lahodny.)

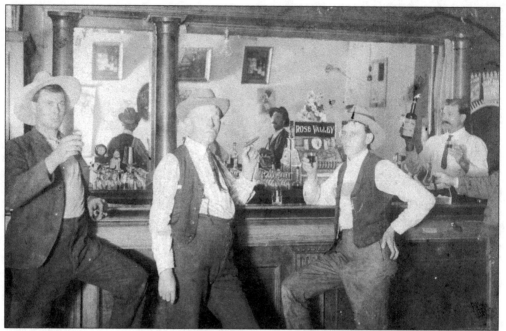

In the 1890s, when this photograph was taken inside a saloon in Praha, the community also boasted a cotton gin, two general stores, a grocer, a post office receiving mail three times a week, and a population of 100. Though the three customers seen here are unidentified, the man behind the bar at the far right is believed to be saloonkeeper Frank Vyvjala. (Vyvjala and Greive families.)

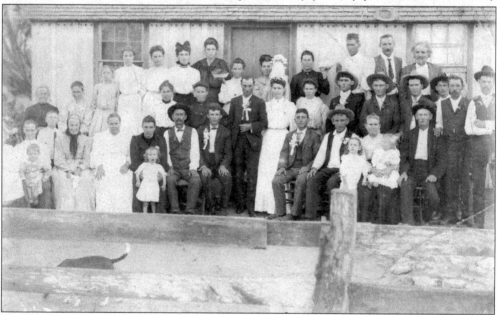

Groom Jim Condl and bride Albina Fojtik pose with all their guests following their 1908 wedding in Praha. This is a rare photograph of an entire wedding party from this time and it shows several interesting small details, like the ladies holding platters of food aloft on either side of the door, a passing dog (perhaps an uninvited guest?), and a hat perched on the edge of the roof. (Jan Zapalac Lahodny.)

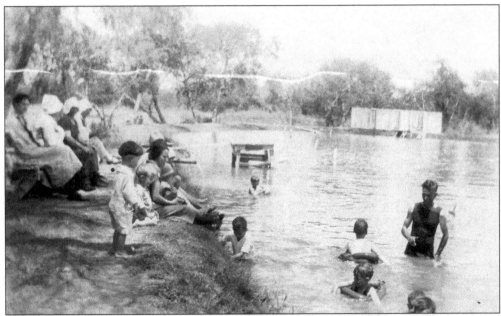

Praha's Vyvjala Lake was the site of many convivial entertainments from as early as 1910, but beginning in 1915, this man-made lake was open only to the paid membership of the Flatonia Lake Club. The large artesian water pool provided a popular escape from the "city." This early water park offered changing rooms, piers, a water swing, boats, and a high diving platform. The young ladies and gentlemen of Flatonia society even enjoyed overnight picnics and bonfires—all properly chaperoned, of course. The club continued to operate at least through the mid-1920s, after which time membership was no longer required and visitors paid only a daily usage fee to owner Emil Greive. The fate of Praha's lake was finally sealed when its artesian wells dried up. By the 1950s, the lake was filled in and the land reverted to use as a cattle pasture. (Both, EAAAM/ Ella Tauch Sievers.)

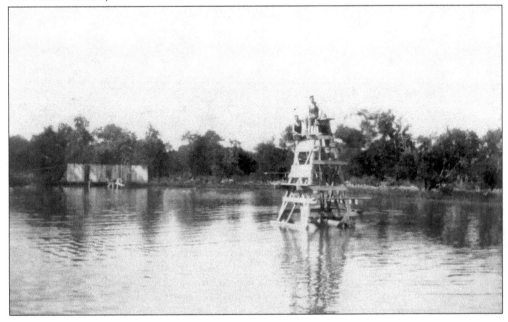

The town of Muldoon was established in the late 1880s with the arrival of the San Antonio & Aransas Pass Railway. A.B. Kerr, wealthy landowner and Texas state senator (1897–1901), built this rock store in 1890 under the name A.B. Kerr & Sons, also known as the Muldoon Mercantile, or simply the "Big Store." It and an adjacent doctor's office, both vacant, are pictured here in the 1940s. (Joe M. Kelly Jr.)

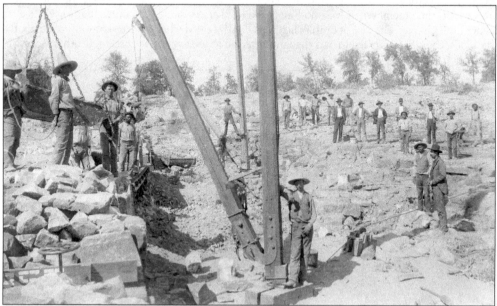

The A.B. Kerr rock quarry, managed by son James Kerr, was once considered the largest and finest in the state. It provided the stone for several of Fayette County's most beautiful and enduring buildings, including the Fayette County Courthouse, La Grange's city jail, and Praha's St. Mary's Church. The quarry sent 35–40 railcars of rock per day to build the Galveston seawall following the devastating hurricane of 1900. (Fayette Heritage Archives & Museum.)

Muldoon's post office was established in 1888. The introduction of rural free delivery meant that farmers and ranchers no longer had to make a trip all the way to the nearest town to fetch mail. Muldoon RFD No. 1 coach and carrier are seen here in about 1912, poised to make their run over long and dusty—or muddy—country roads. (Joe M. Kelly Jr.)

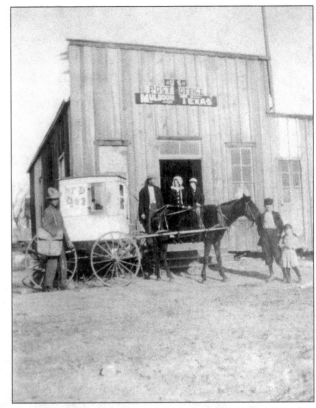

The Muldoon Post Office is pictured here in the mid-1950s with postmaster Pearl Kelly (left) and assistant postmaster Effie Ivy. Muldoon was one of the last communities of its size in the county to retain its own post office. It was closed in 2011, to the great regret of its customers. Though they retain a Muldoon address, they are now served by the post office in Flatonia. (Joe M. Kelly Jr.)

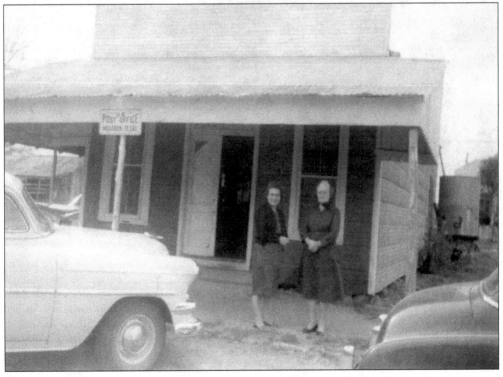

The 1890–1891 *Texas State Gazetteer* lists Muldoon as having a post office, general store, hotel, livery stable, justice of the peace, saloon, and physician. Though Muldoon would experience a serious decline in commerce beginning in the 1940s, the Lueders' store still enjoyed an active trade in the 1930s, when, from left to right, a Mr. Robbins, Bill Parker, a Mr. Ray, and an unidentified man are pictured in front. (Bette J. Boehnke.)

Posing in front of Muldoon's two-room schoolhouse in 1948 are (kneeling with plaque) Bobby Byler; and, from left to right, (first row) unidentified, Garry Warren, unidentified, and Wiley Boehnke; (second row) Barbara Howell, Wanda Sue Null, Sylvia Byler, three unidentified, and teacher Maybeth Bigley; (third row) Devon Boehnke, Thomas Kelly, Tommy Ray, James Allison, Elick Haynie, Jack Fleck, Bobby Wayne Lueders, and Joe Fleck. Students transferred to Flatonia after this school closed in 1950. (Virginia and Harold Boehnke.)

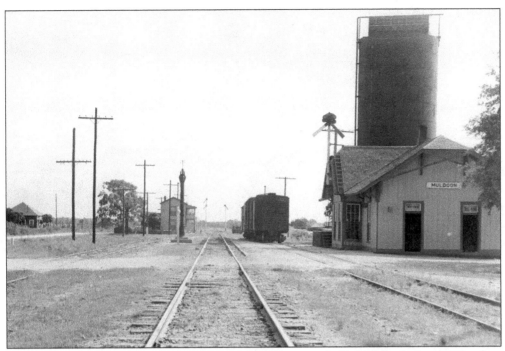

The Muldoon passenger depot, seen here in the 1940s, was probably built in the late 1880s, when the San Antonio & Aransas Pass Railway was completed through this section. In the photograph above, the restroom doors on the side of the building are labeled "white" and "colored," as was then common in the Jim Crow south. The large standpipe seen in the background and adjacent to the depot provided water for the trains. The two-story building with balconies on the opposite side of the tracks was the railroad section foreman's house. In the photograph below, a locomotive-powered freight train steams past the depot. Though there is still an active freight line to this day, the last passenger service serving Muldoon ended in August 1949, when Southern Pacific halted its operation of the Dinky, a two-section train that plied the route between Yoakum and Waco, thus closing the era of passenger rail transportation along this line. (Both, Joe M. Kelly Jr.)

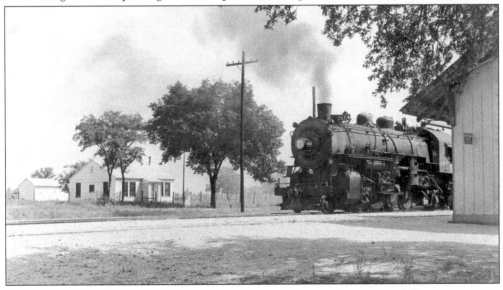

Visit us at
arcadiapublishing.com

CPSIA information can be obtained
at www.ICGtesting.com
Printed in the USA
LVHW010052070520
654940LV00018B/1069